Process of God's Divine Calling

Afi Johnson-Grant

Acknowledgments

───────────◆───────────

Thanks to my son Nehemiah as this book was initially birthed through me getting news of my pregnancy with him. His ministry started from the time he was in the matrix of my womb, where God used his life to rebuild a relationship that was falling apart between my husband and me.

While on a consecration fast, Abbas revealed his life to me which essentially became my testimony for pursuing His purpose.

Thanks to my husband – my best friend, who remained humble throughout all the changes God has and is taking me through. He has been very supportive of Abba's will in my life.

To my step-dad Chen Chin who inspired me to write.

My grandmother Shelia who found it not robbery to train up a child in the way she should go, so that when I got older, I would not depart from it.

My mom Shernett Chin, who did not abort the seed at sixteen years old so that purpose could be fulfilled.

Everol Brackett who has spoken over my life and called out the things of God that were already in seed form, but needed to be planted into good grounds.

Apostle, Dr. John Robert Oduwole who's a Mordecai in my life, giving wise counsel so purpose may be fulfilled.

Thanks to Nicolette Shaw who I encountered on my journey to purpose.

Apostle Narriet Butler who plumb-lined me into moving forward with the plans of God.

Thanks to Apostle Marlene Thompson-Williams.

Carmelata Gordon for being a pillow in my life.

Melisa James, editor and a fellow comrade in the Kingdom of God.

Lastly, to Mutti Lewis for pulling the best out of me through the writing of this book.

Synopsis of What the Book Is About

◆

I thank the Lord Jesus Christ who's my personal Savior, who laid His life down so that I could be acquitted from all my sins. The intended perception of the book is also likened to a caterpillar in its cocoon process.

The caterpillar gives total surrender to its maker and becomes liquefied in the cocoon. Nature's metaphoric transition with the caterpillar shows total trust in the Creator with His creations. This book is about the divine calling of God. Abba Father demonstrates ways in which He will strip, expose and mold you when He's ready for his original intent to come forth for His divine purpose.

His kingdom come, His will be done. Sometimes we start out not knowing who we are because our outer appearances and background might've given other people the wrong idea that we are out of season, but all it requires is the touch of God to bring *His* fruits forth in due season.

We were placed here on earth as beings in human forms but not for ourselves, nor are we alive because we have it together.

Esther was placed in the place that when the fullness of time approached, her divine position as a queen would be utilized to deliver her people...*God's people.*

One's divine calling might be as an intercessor or to make their petition known to the King for a people, but trust and believe that

your position was pre-orchestrated to complete the kingdom assignment.

The book of *Hebrews 12:1-2 states, "Let us lay aside every weight, and the sin which doth so easily beset us, and let us run with patience the race that is set before us, looking unto Jesus the author and finisher of our faith; who for the joy that was set before him endured the cross, despising the shame, and is set down at the right hand of the throne of God" (KJV)*.

God divinely chooses us to go through a process. As a matter of fact, being selected by Abba brings chastening and gives confirmation that you are indeed a son. *"For whom the Lord loveth he chasteneth, and scourgeth every son whom he received.*

He deals with us as sons if we endure the process; for what son is he whom the father chasteneth not? But if ye be without chastisement, whereof all are partakers, then are ye bastards, and not sons" (Hebrews 12:5-8, KJV).

Our Abba Father uses the chastening process to bring forth His peaceful fruit of righteousness through those who are trained by it.

Embracing the divine calling of God will bring the chosen into wisdom and understanding. That is, *"the wisdom that is from above, which is pure, peaceable, gentle, and easy to be entreated, full of mercy and good fruits, without partiality, and without hypocrisy" (James 3:17, KJV)*.

The unfamiliar places our Heavenly Father positions us is divinely orchestrated for Him to get the full glory out of His vessels.

I pray that if you receive a revelation from my life experiences and testimonies, that you will share this book to encourage others as well. The scripture states, *"But I have prayed for thee, that thy faith fail not: and when thou art converted, strengthen thy brethren"* (*Luke 22:32, KJV*).

KEYWORDS *(Merriam-Webster Dictionary)*

◆

Adonai: a Hebrew name for Lord

Almighty: having absolute power over all

Calling: a strong inner impulse toward a particular
 course of action especially when
 accompanied by conviction of divine
 influence.

Clay: a substance that resembles clay in
 plasticity and is used for modeling; *b)* the
 human body as distinguished from the
 spirit.

Creation: the act of bringing the world into ordered
 existence; *b)* the act of making or
 producing something that did not exist
 before: the act of creating something.

Discernment: the quality of being able to grasp and
 comprehend what is obscure: skill in
 discerning; *b)* a power to see what is not
 evident to the average mind.

Divine: of, from, or like God or a god, relating to,
 or proceeding directly from God.

Encourage: to inspire with courage, spirit, or hope.

Formation: an act of giving form or shape to something or of taking form.

Foundation: a basis (such as a tenet, principle, or axiom) upon which something stands or is supported.

Hover: remaining over a place or object tentatively.

Jehovah-Jireh: my Provider.

Intercessor: a person who intervenes on behalf of another, especially by prayer.

Jehovah Paraclete: my Comforter.

Orchestrated: to compose or arrange.

Open Field: an unhampered chance, given an open field to experiment.

Plant: to put or set in the ground for growth, plant seeds, to set or sow with seeds or plants.

Potter: a person who makes pots, bowls, plates, etc., out of clay: a person who makes pottery by hand.

Purpose: aim or goal of a person; b) something set up as an object or ends to be attained.

Running: the action of running – physical condition of running.

Seasons: a time characterized by a circumstance or feature in a season of religious awakening.

Seed: a source of development or growth.

Tempest: a violent wind or storm

Vessel: a container (such as a cask, bottle, kettle, cup, or bowl) for holding something, or a person into whom some quality (such as grace) is infused a child of light

Yahweh: Hebrew name of God used in the Bible. The name came to be regarded by Jews.

Scriptures to Help You Win and

Become a Champion

◆

Ezekiel 3:3 (KJV)

"And he said unto me, Son of man, cause thy belly to eat, and fill thy bowels with this roll that I give thee. Then did I eat it; and it was in my mouth as honey for sweetness."

When you are filled with the word of God it becomes sweet, for you've now equipped yourself to cast down the thoughts and imaginations of the enemy, to be subject to what the word of God says.

John 1:1 (KJV)

"In the beginning was the Word, and the Word was with God, and the Word was God."

Before we existed, God was already in control.

John 7:38 (KJV)

"He that believeth on me, as the scripture hath said, out of his belly shall flow rivers of living water."

If Christ lives in you, then whatever comes out of your belly has to be He who resides in your belly – the wisdom of God through His word, which is God.

John 14:13-14 (KJV)

"And whatsoever ye shall ask in my name, that will I do, that the Father may be glorified in the Son. If ye shall ask any thing in my name, I will do it."

Matthew 6:11 (KJV)

"Give us this day our daily bread."

God who is the Word, is the bread of life.

Matthew 18:18 (KJV)

"Assuredly, I say to you, whatever you bind on earth will be bound in heaven, and whatever you loose on earth will be loosed in heaven."

Revelation 10:8-11 (KJV)

"And the voice which I heard from heaven spake unto me again, and said, Go and take the little book which is open in the hand of the angel which standeth upon the sea and upon the earth. And I went unto the angel, and said unto him, Give me the little book. And he said unto me, take it, and eat it up; and it shall make thy belly bitter, but it shall be in thy mouth sweet as honey. And I took the little book out of the angel's hand, and ate it up; and it was in my mouth sweet as honey: and as soon as I had eaten it, my belly was bitter. And he said unto me, thou must prophesy again before many peoples, and nations, and tongues, and kings."

Romans 8:28 (KJV)

"And we know that all things work together for good to them that love God, to them who are the called according to his purpose."

Table of Contents

Introduction

◆

No one can, on any occasion adequately identify the reason for their life experiences until God fulfills that which he has placed in them for his own purpose. My hypothesis can be illustrated by comparing God the Almighty to the Potter and His creations to the clay. In this scenario, before a potter makes a creation he must first decide what that formation is going to be, including the specifications. Abba predetermines what type of material or body is best suited for the creation of His unique vessel. Please keep in mind the potter has already considered the cost involved in obtaining the ideal material as well as the time needed to achieve his objective for his original intent. This brings me to ask the question, were you ever curious why your life tests differ from other individuals? When a potter makes pottery, he guides the clay on the wheel, so that it can take the formation He envisions. If the object is used to plant seeds, as time progresses the seeds planted in the planter will outgrow the container. The foregoing analogy is applicable to many of us who are placed in certain ministries, families, or cultural bondage. This is the same way the calling of God molds and guides us into His perfect will. After realizing that we are created for a purpose, we become uncomfortable with our limited mindsets and seek room to sprout into our full potential. The prophet Isaiah said, *"Yet, O Lord, You are our Father; We are the clay, and You our Potter, And we all are the work of Your hand (Isaiah 64:8, AMP).*

Abba is a God of seasons. Every tree or plant has a certain time of year for bearing fruits, or displaying how attractive they appear as well as the bright colors which are divinely prearranged for them. Seasons originate to show potential as well as Abba's reason for each plant being rooted into the soil. For example, each child being assigned to mothers womb. Seasons also give the observers or onlookers records of how the Almighty's creations flexes when they are tested in uncontrollable transitions and storms. *Isaiah 49:1 states, "Listen, O coastlands, to Me, and take heed, you people from afar! The Lord has called Me from the womb; From the matrix of My mother He has made mention of My name (AMP).*

One good example is the palm tree. When a palm tree experiences a storm that is catastrophic, a noticeable observation after the storm passes is a slight disfiguration. However, the tree ever so often remains rooted where it does not break. Even plants understand that storms do not last forever. The tempest (violent wind or storm) is designed to test or thrust us into God's divine changes or transformation.

The main reason why palm trees aren't often uprooted is because frequently the average palm trees lose their fronds quicker than the typical tree loses its branches. The palm tree fronds have a resemblance of a feather, so once the leaves depart there isn't much left to catch the wind. In fact, the palm tree understands something that the human nature oftentimes misses. The palm tree has humility towards its Maker because the King

sways it wherever He wants.

Sometimes in life, one reaches a point where he must decide to shed everything including people to survive, because the extra baggage will destroy him and uproot his God-given foundation (which confirms confidence in Him who lives in him). The shedding process gives you the capacity to learn your strength once the storm approaches to test your Jeremiah 29:11 abilities. My point is that the palm tree completely surrenders to its Maker while trusting that this storm too shall and must pass.

Another feature of the palm tree is that it has a pliable trunk with deep-rooted structure to weather force wind compared to other trees such as the oak tree. Although the oak tree has the endurance and strength to *"be ye steadfast, unmovable, always abounding in the work of the Lord,"* and barely sways when the storm comes to test its being or structure, which can sometimes work against its existence. We must have awareness that there are seasons that require strength, while others require humility. The oak tree's refusal to sway with the wind in the storm with the required humility, results in its foundation being uprooted; however, peculiar abilities cause the palm tree to flex with the storm, though it's sometimes left with a curved or bent structure, where it's brought to a low point. The palm tree swiftly rebuilds a root structure again. Seasons come to make changes and sometimes correct our formation, for the next hurricane that will come to test our current growth process. *"To everything there is a season, and a time to every purpose under the heaven"* (Ecclesiastes 3:1, KJV).

Also, many palm trees' growth begin at the ground and continue sideways for a slight distance, then eventually the trunk changes its formation while keeping a low key in height. The palm tree's sideward growth simply shows that *"I might bend but I am not broken," "for the race is not to the swift and the battle is not to the strong"* (*Ecclesiastes 9:11, AMP*). It is imperative that most importantly one endures to the end.

In addition, if one visits a state or country, he might see various categories of trees for the first time. We have a tendency to critique the external appearance without righteous judgment. The reason for our judgments of these plants has to do with our limited understanding, so we often make assessments of things through our natural eyes at a time when it is out of season. The human nature is quick to judge things which are not familiar, due to our lack of knowledge. Some people are under the impression that if everyone or everything doesn't appear, feel, and perform the same way, something is incorrect. Let's be honest, at times when something or someone seems unique to us, we automatically consider them to be unwise, crazy, weird, looney, and a bit off. Seasons in God does not focus on natural formulation, for man cannot begin to comprehend the fullness of who Abba is, lest to figure out a method for what He does. One must be confident that our Heavenly Father is in full control. Think about it, when our Heavenly Father said *"It is not good that man should be alone; I will make him a helper comparable to him"* (*Genesis 2:18*), He put man (Adam) to sleep and created woman, so that not even he would be able to

have the full knowledge of how his helpmate was created, other than that a rib was taken from him (Genesis 2:21, KJV).

Moreover, when God is ready to show forth His glory through His creations such as His mango, plum, and apple trees, there is a need or purpose for the fruits in their divine seasons. Suddenly the trees start to bear fruits in due season (Psalms 1:3). Keep in mind that I am not talking about the trees that men manipulate to produce fruits out of season artificially but instead I'm referring to the plants and trees where regardless of the type of storm that presents itself, one does not have to worry about the crop being destroyed. *"Being confident of this very thing, that he which hath begun a good work in you will perform it until the day of Jesus Christ"* (Philippians 1:6, KJV).

"In the beginning God created the earth" (Genesis 1:11-12) and He said it was good. The Almighty designed seasons to transform, rebuild, restore, and change – the same way the Son of man rose up. Despite how desolate one might appear, it's just a matter of time when the tree's season of restoration will come with a burst of rain and sun to the soil. That is the way God looks at us when He has a divine calling on our lives. The King James Bible stated that, *"In the beginning God created the heaven and the earth. The earth was formless and empty, darkness was on the surface of the deep, and the spirit of God hovering over the water"* (Genesis 1: 1-2). The word hovering is relative to being present over something or someone. The Webster dictionary defines hovering as remaining over a place or object

tentatively.

Whatever state of darkness an individual of divine purpose is in, Abba waits and watches over him. He protects His word that He has already spoken before the foundation of the earth, and in due season He will say *"let there be light"* just as He did in Genesis 1:3. This is where He illuminates truth and one begins to see clearly, so that the things that they were once oblivious to, they immediately gain understanding.

Let me emphasize, we never really identify what is planted in us, or what season our tree will bring forth fruit until Abba is ready to reveal it for His perfect will to be done on earth. One thing we should be conscious about is that we are not created for our purpose but instead exist for God's will in His kingdom. He said, *"Thy kingdom come, thy will be done on earth as it is in heaven" (Matthew 6:10).* He knows the thoughts that He has for us and as a result, we were created to worship Him.

The divine calling does not manifest or show evidence exactly as our spirits are assigned to earthly bodies, but the calling of God starts before we enter our mothers' wombs (Jeremiah 1:5). If we think about it, before the spiritual man was assigned to each body, we were already with God, and that is why we can relate to His word in Jeremiah 1:5. The bible states, *"Listen, O coastlands, to Me, and take heed, you people from afar! The Lord has called Me from the womb; From the matrix of My mother He has made mention of My name (Isaiah 41:1, NKJV).*

God needs bodies to fulfill His will on earth, so as each child is born He assigns the gifts including the type of spirit he or she will need for Abba's perfect seasons. Even though He assigned the spiritual man to the earthly body, God does not deal with the flesh *"for they that worship Him must worship in spirit and in truth" (John 4:24, KJV). "So then they that are in the flesh cannot please God" (Roman 8:8, KJV).*

With that said, no being can stop God's divine calling or plans. When Abba is ready to use His vessels, He will move or destroy anything that "attempts" to come in His way, just for His perfect will to be done. Abba destroyed Pharaoh's army in the Red Sea to free His people from the oppressor who had them in bondage (Exodus 14).

Chapter 1

Early Childhood

◆

As a young girl living on the island of Jamaica with my grandmother and her five children and one adopted daughter, growing up was an interesting experience for me. I cannot say life was challenging; however, I was very much aware that it wasn't the utmost. My grandmother kept the family together and most of all, she planted a seed in my life on good soil. She did her best to *"train up a child in the way he should go that when he is old, he will not depart from it" (Proverbs 22:6).* As I did some deep reflection on my grandmother's laboring, I'm sure she was very aware that my growth would come through Yahweh. The person who plants the seed is not the one who controls the growth. It is He who created the seed that distinguishes the pressure that will thrust the seed to reach its full potential. There are so many people who would like to take the credit for what the Lord Jesus has already predestined, but we know that all the glory belongs to Abba Father who is in heaven.

In the household I grew up in, attending church was compulsory for me and the other family members. We attended the Open Bible Church. I recall my grandmother making mention that my mother lived in the United States, but I didn't think much of it. At such a young age, there was nothing missing from my life. From my ingenuous perception that what you're not attached to cannot possibly cause hurt or

bring about feelings of unhappiness, seeing that there's no memory of connection.

Being so young, I evaluated life through the spectacle of a childish mentality – extremely ignorant of what true beauty was and lacking the understanding that I was fearfully and wonderfully made by God. Blinded by the enemy, I never thought of myself as beautiful (due to not having the so-called long hair flowing down my back). In fact, I considered my hair as a very nappy texture, so as a young girl my self-esteem was essentially very low. The word *pretty* was almost never used in the household I was raised in. Growing up in Jamaica, we were taught tough love. Tough love in many homes simply means that once a roof is over your head and you have food to eat and some clothes on your back, you are loved.

There were times my thoughts got the best of me, such as, "why couldn't I look like other individuals or live in a nice-sized home?" These were a few of the stereotypical things that would run through my mind. My observation of my grandmother was that of an extremely hard-working woman. There wasn't one day that I could say she did not try her best to pursue a better life for her children and me.

From my understanding, we weren't really recognized by the other saints at the church we attended a. There were other children whose parents were more active in ministry; however, I remember there was one December that the church put on a Christmas program and for the first time, I decided to take part

in it. Even though I didn't consider myself of important measure, the night went rather well, and I felt happy about being a partaker of the big Christmas event. At the end of the night, gifts were given out to the children for their participation, which included their Sunday school attendance. In fact, receiving a gift barely crossed my mind, because there were other children who were more well-known than I was. I had already received the greatest gift of the night by simply participating. While sitting and beaming with joy and excitement after being a partaker of singing in the Christmas carols, I then heard my name announced to come up to the pulpit along with another young man whose family was loved by everyone in the church. As we approached the pulpit two of the pastors' chairs were laid out side-by-side. We were then told to have a seat and were crowned as king and queen of the church that night. This offered us certain privileges such as all-expenses paid church trips. I was five years old and the number five signifies the grace of God (Psalms 45:2).

God was already bringing me into His divine calling unbeknownst to me. God knows the thoughts He has for us. Just like David when he was anointed by the prophet Samuel. He had no idea that God had a stamp of kingship over his life because it was the last thing on his mind. David's season was near for there was a giant for him to exterminate. God was preparing David for his season to come. After David was anointed, he went back to live his life as if nothing happened. He returned to what he loved doing, which was taking care of the sheep. When we are called by God, there comes a significant point of our journey where the Almighty presents the perfect setting to demonstrate to others that He has His hands upon our lives. After the demonstration we so often continue to live our lives in such a way that whatever previously had our attention, is the path we continue to follow. Whether that path is good or bad, when the fullness of time comes, we will know Abba's plans for us.

Besides, David was considered as an average Joe as kingship was not in his lineage. It "seemed" as if he was irrelevant because he was just a shepherd-boy tending to the sheep. Can you imagine how others viewed him? He was most likely perceived as smelly, dirty, and not to mention that his garment wasn't up to par. This is another example of how we can view a tree when it is out of season, while not knowing the full potential of an individual or thing. As a matter of fact, the scripture shared that Goliath ignorantly cursed David. He too had his perception of this anointed vessel of God (1 Samuel 17:43). God was hiding David for a specific time such as the Goliath era.

God knew what He had put in David for the season of Goliath and He had divinely placed a warrior in him. The deposit that Abba (God) has put into each vessel is perfectly equipped to successfully accomplish its God-given purpose. Saul told David that he does not have the ability to go up against the Philistines because he was just a young boy. Saul said this ignorantly as David was already equipped for a giant like Goliath and was victorious in battle. He was already going through his process (by ways of his experiences), away from everyone. David fought many fights when nobody else was around. The only witnesses were him, God, and the sheep. He defeated the bear and lion that the average person dared not challenge (1 Samuel 17).

Have you ever gone through something that was designed to take you out? Something such as a storm or trial that family and friends hardly had a clue about, and it was solely the grace of God that kept you? In fact, when people see you, they can't begin to comprehend the storm you came out of because there is no remnant or scratch to depict that you are a survivor. The only evidence you have is your testimony. The Almighty knew that He had already molded David to bring down a giant that everyone else would be intimidated by. David was already designed by the Potter for a season when the angel of the Lord of Hosts would fight on his behalf – a season where God would ultimately exalt him. There were many others who were structurally framed, but for the Goliath soul, they would not stand a chance because the Potter was ready to showcase David. David was anointed by God and not appointed by man.

In other words, everything concerning David's Goliath season, was already in him before the foundation of the earth.

Chapter 2

A Mother's Stern Hand...

Was it Necessary?

My early childhood education started at the Barracks Road Girls School in Jamaica. While attending primary school, I met a young girl who was the same age as me. I brought her home and from then on, she lived with my family as it was much easier for her mother and other siblings. She was now a part of God's divine calling in my life. I then learned to want the best for my neighbor as I would for myself. Four years later God relocated me from Jamaica to live in the United States with my mother, at nine years old. The number nine represents the fruit of the spirit's divine completeness, for God brought me into an unfamiliar land to complete His divine purpose in me. My mind still did not comprehend that this was also a part of God's divine calling. How could I possibly grasp what was happening to me? Everything I knew was now being ripped away because I moved to a place which was unfamiliar. Moreover, I only had to be strong and of good courage, for this next stretch of the journey was one that I had never experienced before.

After moving to the United States with my mother, younger brother and her youngest sister, I had to adjust to an entirely new environment. Church was a necessity for us, even

though my mother rarely attended service or assembled herself with the saints on Sundays. There were days we gave our offerings, some where we bought candy and others where we got into fights. Imagine how God chuckled at us. Whenever we started trouble in one ministry, we'd attend another organization the following week. Thank God for looking beyond our faults and seeing our needs. Maturing into my early teenage years, we met a couple who would take us to church every Sunday. At this point in my life, going to church was something I looked forward to doing because we were given the opportunity to spend time away from my mother.

My mother has always been a hard worker and was the only family member we had in the United States. Therefore, one can understand the load that she carried and the level of stress she had to bear. The words that came from my mother's mouth were not the sweetest melody one would want to listen to. One would consider the majority of the language she used as inappropriate both privately and publicly. As previously mentioned, my mother did not raise me in the early stages of my childhood and my grandmother was my guardian. My mom wanted a better life and opportunity for her entire family. As a result, she made the decision to move to the United States, where she would gain the ability to bring all her siblings and their children into a better and more rewarding lifestyle. We often refer to my mom as the sacrificial child of the family because she gave up almost everything at the age of 20 years old. With that said, I did not have the opportunity to build that

mother-daughter relationship with her. She was sometimes very offensive verbally and physically and because of that, I did not extend my love to her freely. In other words, I disliked the way she handled her authority over my brother and me. Let me admit that there were times when I disliked being in her presence. Unbeknownst to me and as I would soon find out, I was facing all of these experiences head-on because there was divine purpose waiting to come forth through me in due season.

As parents, we must be mindful of the words that we speak in the atmosphere about and to our children. Parents can decree and declare purpose over the seeds God has given them and direct them the way they should go. Ignorantly, because of lack of knowledge, we unconsciously provide the enemy with ammunition (words) to use against our seeds (children), to kill them before they have a proper chance to grow. Then we go into prayer asking God to change our kids, open their eyes that they may see, etc. First and foremost, there are words that the prince of the air has against them which were never taken out of the atmosphere. As a result, it is therefore necessary to first denounce everything that was said, even the ones you've forgotten. It is imperative to do the aforementioned in the name of Jesus and decree the will of God over their lives.

At this time of my life, my self-esteem grew really low because of the things that were verbally uttered to me. I did not feel worthy of anything, and the happiness in me was now dying. Whenever God is getting ready to bring forth a change in something or someone, the enemy tries to destroy it before it reaches the growth process of comprehending truth and purpose.

In this season of my life, all I had was my tears and a song. During this time frame, there were songs that encouraged me. Songs such as *"One Day at a Time Sweet Jesus"* and *"Draw Back the Curtains of Memories."* My tears would just roll down my face. These were the kind of melodies my grandmother would sing when life appeared dim. Me, the seed, was oblivious that the divine calling of God required me having some rough experiences when we step into our own will and not His. *"And we know that all things work together for good to them that love God, to them who are the called according to his purpose (Romans 8:28 KJV)."* When the trials came my way, my inner spirit desired not to break but instead stand against the wild vicious claws of the devil.

My relationship with my mother grew extremely poor, especially when she learned that I was pregnant at the tender age of seventeen. I was overwhelmed with shame, being pregnant at such an early age. I know everyone was looking down on me which often put me in a precarious position and often made me feel like I didn't belong. I could feel their unrighteous judgmental eyes and condescending spirit breathing down on me, or was it my own guilty conscience and heart that was weighing me down? I had thoughts of abortion several times but as I wrestled with it in my spirit and the unborn child in my womb cried out for mercy, I was now charged with making this extremely difficult and painstaking decision and to top it off – as a teenage girl. To abort or to not abort? God knows it was not easy. After a while of wrestling with myself and crying out to the Lord, my spirit became calm and I gave in to the silent little voice that knows me more than I know myself. I ultimately made the decision to

accept living with my shame rather than taking the route of abortion.

Getting ready for motherhood at such a tender age is something I know many women can identify with. Could it be that I was rebelling against my mother's strict ways of parenting when it was my grandmother's that I knew? A woman with a completely different approach to life coupled with my low self-esteem or was it love that I was yearning for in all the wrong places? Whatever the reason(s), the Lord knew best or else He would have never allowed this pregnancy. Knowing that several of my friends in high school had gone down this very same slippery slope that I had now found myself on. I knew this grave mistake that had now caught up with me was for a specific purpose. Yes, I could call it cause and effect, but I choose not to. Perhaps there were life lessons in it for me to learn. Who knows? Time would certainly reveal itself.

It wasn't long after, that I learned about the news of the father of my unborn child's incarceration. What do I do now? I'm pregnant and alone to figure it out all by myself. My thoughts were "Oh God, I need your intervention before I self-destruct." As if all that wasn't enough *for one person to deal with*, I was constantly spotting and soon found out that I was dealing with a high-risk pregnancy. In my diminutive mind, everything for me was now dead and my life from then on would go downhill. Before total bewilderment could set in, and not too long after, my grandmother migrated to the United States Was this God's plan or what? God was now ready to make the Jeremiah seed that was already within, gain full awareness that he was

completely in control.

One night I was sitting in the settee (sofa) next to my grandmother and without my permission I began sobbing, with no control over my tears flowing. Everything in that precious moment was out of my control. It wasn't a sad or bad feeling; however, my mouth opened to sing the song *"I Surrender All"* while weeping. Everything that I knew how to do or seemed familiar with, had now packed up and left me by myself. This was the perfect opportunity for the Potter to come in and mold the pottery. When you feel like everyone has given up on you, then Adonai will step in. Things were not working in my favor, at least not according to the way I thought they should flow and furthermore, this too was a part of God's divine calling. My life felt nothing short of shattered. Every dream seemed as if they would never be realized. Besides, I had to acknowledge and face the reality of my current circumstances, where the doctors were planning on giving me an early C-section; however, God gave me the miracle of having a normal delivery. As a result, my son was born a little over seven months. After giving birth, the hospital kept him for two weeks; even though the reasons remained unclear.

Here I am on a different path – one not a part of *my* plans. Please take note that I said "my plans" because the divine calling of God cares nothing about our plans, but solely concerning His will being done on earth through his chosen vessels. Thy kingdom come, "His" will be done (Mathew 6:10). I had my first child out of wedlock at the age of seventeen, for a man I thought I loved. One who I assumed was going to be there for me but

only to realize that he was a drug dealer. I thought I was in love with this young man who was so full of potential and could have done so much with his life, had he chosen to take the road less traveled instead of the fast lane that often leads to destruction - that of a quick-fix dealer. Was I that insecure? Blinded by empty words? It was this sad youthful experience, turned into a forbidden lust that led me on a sinful path. I was young, stupid, and basically gullible. Was I aware of his doings or was I truly ignorant of the truth? Did I only see the truths that I wanted to see? All I know is that I was stuck between a rock and a hard place. Meanwhile, most of my friends had moved on to college. There I was experiencing these quick flashes of what my life could have been like, yet now delayed (*not realizing it doesn't mean denial*). But maybe God had a better plan for me, but only time would tell. I was left to care for a child without a father. The things I told myself could and would never happen to me had evidently manifested itself in my life, but that's alright because it was working out for my good. What happens next? I didn't have the slightest inclination where my unborn child and I would go from here? Only God knew!!!

Chapter 3

Experiencing God in a Different Way

◆

Abba wanted to have an encounter with me. This was an area of unfamiliarity. There were so many things going through my mind. During a time of reflection, I was invited to a convention on purpose. The speaker was a mighty woman of God. She instructed the congregation to bring a white handkerchief. While sitting in the audience, she moved in the spiritual realm with such authority & power. This was nearly unreal to me because as far as I was concerned, God could not have moved in such a supernatural way. "Wow!" Being in an atmosphere with such power was incomparable to anything I'd ever comprehended supernaturally. Here I was sitting in an audience of believers – some crying and in tune with what was going on. My thoughts were of mere disbelief as it was almost abnormal to see this woman operating in the spiritual realm, as God permitted. The prophetic was foreign to my natural understanding and I was ignorant to the fact that humanity had access to Abba's gifting on earth.

She then looked over and said, "Young lady come here." Me being who I was, had tons of question signs spinning in my head like a hula-hoop, so I gazed around me to see who she was referring to. Taking into consideration that this was my first time seeing her and having no knowledge of the

supernatural movements, I was simply, naturally, and honestly out of my element...at least in my thoughts. She then said, "Yes you!" Curiously and hesitantly walking towards her with my new born baby, she reached for the handkerchief I brought with me and laid it over my son's back and his face three times. Then she uttered these words to me. "Do you know what I'm doing?" Before I could reply, she said God is finishing the development of his lungs. The number *three* signifies divine completeness and perfection. At this point my only reaction was that of tears falling from my eyes because something was happening, that I was unaccustomed to, it felt just right. There was no explanation to sum up my emotions. She then began to tell me about my entire past – all the abuses and hurts I'd gone through. Then she embraced me and said, "God said it is not your fault." At that very moment, something touched me. My tensed shoulders drooped and my heavy heart became weightless. It felt like someone came and took the baggage I was carrying for years. I was now heading into the divine calling of God and my spirit knew and received it, though my natural man was still trying to apprehend what took place. I felt like Paul in Philippians 3:12 where I was trying to apprehend that for which also I am apprehended, for my spirit was in tune yet my flesh was still trying to figure out what had taken place.

The Apostle that God used to open my eyes to His supernatural movement had just started a new church, so I began to visit her ministry at my free will. When you encounter God's touch, no-one needs to force you to assemble yourself with those who are stronger in the kingdom of God. The first day

I attended and sat amongst the congregation, she asked me if I desired to be filled with Holy Ghost and I answered yes without a doubt. Moreover, my desire was to know this God that spoke through her- the voice that understood all I've been going through without me saying a word out loud or broadcasting my bio. My spirit wanted this gift which was impossible for me to interpret because it was obviously not English or patios (pat-wah) – the only two languages I was acquainted with. Little did I know it was already there and just required being reconnected to the original intent of God.

This experience felt so real and was another step drawing me closer into the divine calling of God – the living God my grandmother had always believed upon. I had now experienced a miracle after gaining a better understanding of what took place. The woman of God told me to hold the communion table-cloth and immediately as I opened my mouth, I began to speak in an unknown language. I tried to correct the sound which was not of my doing, but it kept rolling off my tongue. The preparation God had for me did not take me through the tarrying and slobbering process. Abba knew just what it took for his perfect will to be done in my life. The traditional religious preparation in the Pentecostal church, was not a part of my make-up. My God in heaven was preparing me in a remarkable and unusual way.

Now that I had an encounter with my heavenly Father, I kept my body holy. Yes, I lived a holy life for two years until my son's father was released from prison. In my flesh, I really

thought "I" had it together after having such an experience with God. Be careful not to think *you've arrived* once you've said yes to God, because the work has only just begun. I was faced with many challenges that I needed to overcome—all the weaknesses which required a process in God to transition to the next level of His will. My son's father came out of prison as a Muslim. The enemy realized I was on a path into divine purpose, where Abba's will would cultivate me into His full course. The seed that was planted had already been persuaded that Jesus Christ was (and is) Lord. The ministry I joined had just called for a forty-day fast, and during this time my son's dad asked me to marry him. No one knew of this. I intended to cross the threshold into deep reasoning with my Heavenly Father "you know the secret place...and asking the Lord Jesus to give me direction, as if Abba didn't already hear the conversation."

News flash! One should not put multiple types of plants in the same pot because one might destroy the other. During the fasting and while enrolled at The Community College of Philadelphia, my son's father told me he had another child the same age as my son. He shared this information the week of my finals. The news he released was very troublesome to my heart. *"For we shall know the truth and the truth shall make us free"* (John 8:32). *"These things come through fasting and prayer"* (Matthew 17:25). No need to wonder how the update affected my scores. I did such a decent job at botching every test given.

The congregation was required to assemble themselves the last day of the fast. Upon entering the building, the apostle called me to the pulpit where she was standing. Fearing the God who

was in her, I pondered to myself, "What will she say to me now?" My heart was conditioned for the truth, whether or not it was conducive to my flesh. Letting every guard down and prepared for an open rebuke, I was now ready to deal with the truth and the consequences. In other words, whatever came out of her mouth was from God. Well I made my way to the pulpit – though not too excited as I moved forward with an open mind. Then she began to minister to me saying, "Abba said he is not your husband. Wait on me said the Lord. Wait on me. God said I have your husband and holy, holy is he." This was another demonstration that God is a prayer-answering God, even if you pray silently without uttering a word.

This reminded me of the woman in the bible by the name of Hannah who wanted son by her husband and the priest Eli told her to go in peace – that the God of Israel may grant her petition that she had asked of him. Eli told her, *"Let thine handmaid find grace in thy sight. Hannah went her way, and did eat, and her countenance was no more saddened"* (1 Samuel 1: 17-18). My spirit received every word she said without a fight. It was almost as if the kingdom seed in me said, "Let the church say Amen!" My decision to part from this relationship happened immediately because I desired to walk in Yahweh's perfect will. The relationship ended quicker than a moving train. He went off the scene for months...maybe a year.

Chapter 4

Trusting God Beyond Your Feelings

◆

The divine calling of God will not permit you to include possessions or people who are not called to enhance or thrust you into the presence or purpose of God's plans. While pursuing my relationship with God, so many obstacles came to distract the growth of the seed previously planted in me. Have you ever observed a seed in the ground that had been chewed on by all sorts of insects? When carefully observed, it's amazing to see that there's still a small leaf bursting out, showing signs that life still exists. In this season of trusting God, there was a point where I did not have a stable location to lay my head. My lack of understanding plagued and led me to assume that the God I've heard my grandmother dialogue with and the Father I encountered, had packed up and deserted me at my lowest point. The enemy wanted to capture my mind, which is the battle field. Yes, even the devourer distinguishes when we are divinely called by God; he was trying to hinder me from the Jeremiah seed's full potential. Anyone Abba elects is a threat to the adversary's plans because from the days of John the Baptist until now, *"the kingdom of heaven suffered violence, and the violent take it by force"* (Matthew 11:21, KJV).

Sometimes our trials leave us with tons of question signs. Well, at such an early stage of the divine process I was soon to detect that the thoughts God had for me was good and not of evil, with an expected end (Jeremiah 29:11); however, existing was like being in the wilderness by myself. There are

some individuals who have the ability to quote scriptures with their eyes closed and can tell you the exact location for the scriptural verses. Please don't get me wrong, there's absolutely nothing wrong with having such capabilities, for the bible states that one should *"Study to show thyself approved unto God, a workman that needed not to be ashamed, rightly dividing the word of truth (2 timothy 2:15, KJV).* Quoting a scripture doesn't necessarily provide evidence though that you believe it. The word *must* become flesh and abide amongst you. Nevertheless, soon I would have a better understanding because my circumstances had now propelled me to trust the word of God.

The divine calling of God requires His chosen vessels to have confidence in His process, especially when we can't hear His voice. Not hearing Abba Father does not mean He's ignoring us. The Almighty has already provided us with the necessary tools we need to pass the tests. In the natural, when a student is taking an exam, the instructor remains quiet. The reason being, the instructor desires that the student does well in the next level of his learning path so therefore, the Teacher (Abba) knows that it's imperative that one learns to navigate through life and figure out his way, in order to survive the next level of advancement.

In this deserted time of my life, I distanced myself from everyone who contributed or caused me to hurt, so oblivious that this was all a part of the divine calling of God in my life. Sometimes Abba will take you away from everybody and everything you are familiar with. In other words, *"Trust in*

the Lord with all thine heart; and lean not unto thine own understanding. In all thy ways acknowledge Him, and he shall direct thy paths" (Proverb 3:5-6, KJV). God desires His people to trust Him as we enter His divine process. The word of God also states, "He who has begun a good work will complete it until the day of Jesus Christ." Jacob was by himself when he wrestled with the angel; Joseph was away from his family amongst total strangers.

In the process of being homeless, my one-year old son and I went to stay with a friend in a one bed room apartment. Indeed, there were thoughts to walk out of the will of God; there would be no accountability but instead free access to appease my flesh, disregarding the consequences whether it was good or bad. In other words, let's just say my main goal was to essentially make a better life for my son and me – regardless of what that looked like or equated to. The truth of the matter is that my motive was to look for the easiest way out, which would provide an immediate solution. Just as the flesh would desire, the solution I came up with was to be a dancer at night and a mother and student by day. Which reminds me, Baba (our Father) knows the plans He has for us – which is good not of evil (Jeremiah 29:11). In the process of dealing with being a single mom, not having a place of my own, on the edge of losing my part-time job as a waitress, attend college, and trying to hold everything together hoping that everyone didn't consider me as a complete failure, I realized that the burial state of my personal outlook had nothing to do with God, but instead everything to do with

having the Jamaican cultural mentality. We so often try to live our lives to please the people around us or make-believe to have balance, while our inner man is crying out for help. In fact, many times the very people we focus so hard on and think to be in good standing with their will over your life, haven't even tapped into the real authenticity of who they are. This is something to really ponder.

With that said my human structure became ill and my entire body grew stiff, to the point where I could not even move my neck and every ounce of my limbs was in extreme agony. We often say to ourselves, "I really don't care what people think about me," but the reality is, we really *do* care. On this emotional roller-coaster journey of trying hard to prove that I didn't fail – even though my world had already fallen apart (in my carnal mind), I realized that Abba will never leave you nor forsake you. The fact that I was dealing with so much hurts and trials, the enemy wanted to take me out with a nervous breakdown but in the eye of the storm I found refuge in the Almighty. Thank God for His word that says, *"God is my refuge and strength, a present help when in trouble"* (Psalms 46, KJV).

In my season of testing, I met this young man who until this very day is like my big brother. The Lord knew my intent, so He strategically placed him in my life to encourage me not to venture in the direction of becoming a dancer. One day my big brother looked at me and said, "Dancing is just not for you." When making life decisions, whether we are honest enough to acknowledge it or not, we've already distinguished what is right from wrong. Moreover, it's imperative to have at least one person who will express truth – whether or not we approve of

their opinions. Even though I had taken a vacation from assembling myself with the people of God, who I deemed as the religious folks, it would become evident that Abba divinely placed my brother in my life for a season...to illuminate hope.

My big brother – though not biological but instead through a spiritual connection, opened his apartment to my son and me. We stayed with him for a short period and he showed great loved towards my son. He tried to help me the best way possible by working in the day and in the evening, watch my son when I attended college. Trying to keep myself above unchartered water, life became difficult for me to take care of my son while attending school at night, but all the struggles and trials would eventually make me strong someday...beyond my understanding. As I remained strong and took life one day at a time, there was a phrase that kept me daily during my deep reflections. The phrase I used during this area of my journey was *"I'm still alive!"* The divine calling of God will not allow you to die in His process of making you according to His perfect will; instead it'll cause you to reflect on His word that states, *"Be strong and of good courage, fear not, nor be afraid of them: for the LORD thy God, he it is that doth go with thee; he will not fail thee, nor forsake thee"* (Deuteronomy 31:6, KJV).

Chapter 5

Process Taking Place

◆

I had now moved on to the next chapter of my life. I met a young man in the process of trying to understand myself and what God was doing in me. The divine calling of God doesn't always mean you know exactly what is happening to you; one just needs to know that it's not constantly a comfortable situation. When process is in place, the plant or vessel must continue to have a desire to press, despite the discomforts that are presented to bring them into their full potentials and beings. Moving forward, we decided to move in together where he helped me to purchase a home at the age of twenty. We lived together for two years then separated for a year. Time apart aided me to go through the process of finding more about what and who lived in me, where I was now being pushed into discovering my true identity.

In the process of self-discovery, the only desire I had in me was saying yes to a relationship with this Man that won my heart that I'd never seen. This man was God Himself. My only surety of experiencing Him was building a personal relationship in spirit and in truth. *"Jesus said unto Thomas, because thou hast seen me, thou hast believed: blessed are they that have not seen, and yet have believed"* (John 20:29). After a year of separation, we decide to reunite in marriage. In my natural mind, marrying this young

man would fix my past hurts and bring joy in every possible way. The divine calling of God must be fulfilled, for He holds the plan for our lives. The key ingredient is to operate in the fruit of the spirit. This would require walking by the spirit and not gravitate to the desire of the flesh (Galatians 5:16, 22-23).

As believers, we tend to have this perception that once the wedding vows are exchanged, everything from there onwards is an easy ride, we also tend to place a lot of emphasis and attention to the fact that our bed is undefiled. I made a promise to Abba (Father), before I came into the union with my husband, that whatever my experiences are from this point of my life, I would not pretend but that instead my life would be an open book to help others. My life would now become an open book to the people around me because the divine calling of God brings you to a place of truth – true transparency and learning to understand more about the divine calling of God. In my current state of discovery, life appeared pretty decent, such as, no longer having to deal with homelessness and now having a sense of balance. Just imagine not having to worry about what you're going to eat and where you are going to sleep. This was truly a breath of fresh air.

I was now a member at a ministry where I assembled regularly with the people of God. We proceeded with wedding plans. Both our families flew to the island of Jamaica and stayed at the Sandals Beach Resorts where we would take our vows. The night before we said "I do," the need to reason with my Heavenly

Father was heavily impressed upon my spirit, so I went out to converse with Abba on the ledge, surrounded by the water on the resort. The only sound that was noticeable to me was the roaring of the sea water. The stars also appeared extremely close in the sky. It was as if one could reach out and touch them. As I was walking out to the ledge, I felt like something was shifting within my spirit, and tears began to roll down my face. I couldn't even utter a word out of my mouth. One would think this would be the perfect and intimate atmosphere to converse with their creator. At this present moment, I felt like Hannah – where even though I said not a word outwardly, every word prayed within was answered. It was almost as if I took a super-spiritual leap into the divine calling of God. I was in for a treat for my Abby Father was ready to download and release another level of understanding to me.

The divine calling of God is a process. We took our vows, and yes I was bombarded with thoughts and questions like, "what in the world have I done?" "Is this really going to fix anything?" The truth is I was not in love and that's because I didn't fully understand what true love was. Fear gripped me and there's no fear in true love. However, this was undoubtedly a better place than where I was a year prior. In any event, we headed back to the states where *life happened*. We found out that I was pregnant and my husband was very excited. I wasn't sure of how to feel, but I'm sure it wasn't the same joy he expressed. In fact, I was well caught up with my body and did not want to ruin my figure. Nevertheless, we had a beautiful baby

girl nine months later.

A lot of believers fight with putting their flesh under subjection, but by this point of my journey, fornication was no longer my issue. On the flip side though, I was married to a man who showed no desire to serve God. I learned very early that I had to be strong in the Lord and the power of his might (Ephesians 6:10). Convincing him to attend a church service with me was like trying to pull an angry bull that was ready to attack at any given time. My work was now cut out for me, but I kept my faith in God, as well as kept his name in prayer...that Jesus would save him. Many times, wives want their spouses who aren't persuaded, to say yes to God right away, so that they can portray this perfect Christian family. Notice I said "Christian." The reality is, coming together is of no essence to God if purpose isn't connected to it. There are times when we step out of the will of God and into our promiscuous will. This oftentimes cause challenges to become more than what was designated on the journey. It's unfortunate that the very ones you are very closely connected to, such as, your children, spouse and friends, can possibly be the very individuals used to bring spiritual growth. I believe God uses the ones who we are close to because we count the cost of just walking away. Marriage speedily pushed me into the divine calling of God in a way that I never imagined it would.

The challenges of marriage which is a ministry by itself, propelled me to seek God's face more than with previous trials. Through this process, my spirit was yearning for more of God. I was what you'd refer to as a *relationship sprinter* – meaning that

I kept my heart close to me and didn't allow anyone to come too close. Whenever my relationships became challenging, it was pleasuring to simply pack and walk away. Detaching myself from the relationship made it easy to start over if things didn't work out the way I planned. Majority of the times my bags remained packed, ready to walk away from my marriage. Moreover, how could this possibly be the man that God had chosen for me? The truth is God doesn't choose for us; He gives us free will. My lack of maturity made me ignorant to process in God because the ground I was planted in was specifically designed to bring forth a tree rooted for the divine calling of God.

This relationship was intended to cultivate my spiritual man to a higher place in God. Because all I ever knew was to run, the divine calling of God was pressing me into pure gold (Job 23:10). I thought that perhaps I really messed up this time around and as a result, this was manifested punishment from the Almighty. When in our broken state, we tend to pray and ask God things like where is He" Why? Because the discomforts tend to make one believe that such experiences just cannot be included in Abba's course. Some individuals are under the impression that only good things happen to the people of God when they say yes to His will. With this in mind, when Abba's purpose and process commences, we tend to point all fingers to the enemy. When one decides to say yes to Christ, *"He must deny himself, take up his cross, and follow Him" (Matthew 16:24).* I progressed to another level of God's divine calling where he wanted more of me.

Purpose is birthed through the seed's process, with our

assignments attached. The story of Ruth and Naomi is a good example. When Naomi's husband, Elimelech died, she was left with her two sons. They both took wives one by the name of Orpah and the other Ruth. Years later, both sons died, and Naomi was left with her two daughters-in-law. Naomi tried to abort the process, but her assignment would not leave her. Our assignment is predestined for God's purpose. Orpah wasn't the assignment; Ruth was. Sometimes we are ignorant regarding our assignment which is ultimately connected to the purpose of God. The assignment stays with the chosen vessel until the purpose recognizes the connection. It doesn't abort even when we desire for it to go. The assignment then looks us in the eyes and says, "Entreat me not to leave thee, or to return from following after thee: for whither thou goest, I will go; and where thou lodgest, I will lodge: thy people shall be my people, and thy God my God: Where thou diest, will I die, and there will I be buried: The Lord do so to me, and more also, if ought but death part thee and me" (Ruth 1:16-17). As we embrace the assignment and purpose, then and only then will our current situations change. The plans of God are yeah and amen. They do not change for His will **must** be done.

Chapter 6

Process of Breaking to Build

$$\blacklozenge$$

Now here I am in my boxed mentality, assuming that life was okay because I was in control of my feelings and felt it would be much easier to walk away from my relationship and just start over. In my mind, God would bless me regardless of whom or what I left behind. With my limited understanding, it was time to move on...not realizing that God knew that the relationship I occupied would break and build me in numerous ways. My case was already built with all the reasons why it was best for us to separate, such as, no longer being attracted to him, especially because I didn't believe he wanted to have a relationship with Jesus. Silly me with my little judging book, thinking I knew the future. These were just some of the reason for my verdict; however, they were many. Five years later when I was in the fifth month of fashion designing school, my next move was to relocate to another state with my sister. My mind was made up because once again, running was an easy avenue when it came to my feelings.

But...here came the surprise. I was pregnant, with no desire to have another child. I knew pregnancy would only spell out a setback, and I just couldn't afford to deal with putting my goals on hold another second. The only part I misunderstood was that in God there are no setbacks, for everything works out for our (His) good (Roman 8:28). Even though I was filled with

the Holy Ghost – speaking in tongues and you name it...God knew in my heart that abortion would've been my decision. Nevertheless, here I was pregnant with another child for my husband. The even funnier thing was, I didn't discover this until my fifth month into the pregnancy. The continuous flow of my menstrual cycle gave me no reason to be concerned. I believe God intentionally hid this pregnancy. Having had any knowledge of this pregnancy any earlier, abortion would have definitely been my decision. **YES!** I would have destroyed a piece of the puzzle which was created to open my eyes to God's divine plans for our lives. If you notice I said, *our lives*. No longer my life *"for you shall know the truth and the truth shall set you free"* (*John 8:32*).

There were two women in the Bible by the name of Shiphrah & Pauh. They were told by king Pharaoh to stoop when delivering the Hebrew women babies and if it was a boy to kill him, but the midwives feared God and did not abort God's purpose. *"When summoned by Pharaoh the Hebrew midwives told him that the Hebrew women are vigorous, healthy, and lively and give birth before we get to them"* (*Exodus 1:15-22*). As a believer, we too must take on the same spirit, so the plans of God may prevail.

I remember going on a week of fasting and praying and telling God I'm tired of living this life. I really wanted out of this high-risk relationship. *"Lord, please do something to change my husband's lifestyle,"* *I prayed.* I didn't want to end up with a husband dead or in jail and having to raise my children by myself. I began to break generational curses off my life supernaturally. My observation that most of the women in my

family ended up alone or became single moms was enlightening to me. I began to speak into the atmosphere, decreeing and declaring that this path would never become my portion. I began to really fear the hands of God during this duration of my pregnancy, so I made the decision to deal with whatever trials came while carrying our baby.

While in fasting, asking God to change my husband's lifestyle. My husband began to go through a season of challenges. I was prepared to go through whatever storms came our way. I'd now seen the hands of God, but didn't realize that such a storm which would produce such growth of faith in God was coming. *Be careful what you pray for and be ready for Yahweh's answer.* My husband decided to walk away from his quick fixed lifestyle and took the step of attending school to become a commercial driver. This would require him leaving his family for a couple of weeks for training, and then a year on the road to build his driving experience. This too was a part of the divine calling of God.

The first month my husband was away, resigning from my CNA job was the inevitable because the pregnancy became more and more demanding. This resulted in there being no income and the bills began to heap up like a stack of papers to be filed. The eye of the storm had now hit with intensity, but there was a seed that was planted in me from a little girl in the island of Jamaica that was now ready to come forth.

Chapter 7

Trusting God as Jehovah Jireh

◆

The divine calling of God was now ready to shift me to another level. Moving to the "other" level oftentimes requires the sudden emergence of a storm which doesn't give one a chance or any signs to prepare. While my husband was away training as a commercial driver, we began to face financial issues. The utilities were being shut off, but I kept myself entertained in the presence of God. In the early morning hours there was a significant sound, such as a knock. I quickly realized that it was my hour of reasoning with God (Isaiah 1:18) and all I began to know was worship and learning more about our loving God.

One day as I was sitting at home about six months into my pregnancy, the water company was dispatched to disconnect my service. The utility man looked at me and asked, "Miss, can you write us a check?" I responded to him and said "Sir, I'm living by the grace of God." I also told him that I understood that he had to do his job.

After responding to him, I shut the door, but my windows were cracked, as it was one of those hot summer days. I felt the spirit of worry, sadness, and depression trying to penetrate my heart. Suddenly I began to sing the song "God I won't complain." I believe the man must have heard me singing because a few minutes later, I heard a knock at my door; it was the

same utility-worker from the water company. He looked at me and said, "I'm going to leave the water cracked for you, but I don't know when they might notice and send someone else to shut it off completely."

I was now experiencing a combination of faith and favor. Yes, as a young girl in Jamaica my grandmother believed God for things I thought was impossible. The divine calling of God was pulling out the strength He had already planted in the roots of the Jeremiah seed, which I had no idea was in me.

My husband would call home frequently to make sure the family was doing well. It was very important to me to not alarm or worry his mind, so my response would always be "Everything is just fine". The testing of life wanted me to blame him for our current situation; however, let's just say I wasn't ignorant of the enemy's devices. I decided to begin referring to him as my "better half." Essentially, as a people we like to blame or point our fingers at who's wrong; however, having discernment helped me to understand that this storm did not come to terminate, but instead unveil what was in the structure of the building. Please be mindful that we are the church (Matthew 16:18) and sincere prayer changes things.

Even though my husband was away, he began to experience the effects of the storm. There was one day in particular that he called broken, while telling me how awesome God is. My husband found it necessary to speak about the reality check he was experiencing in his spirit. While he was

speaking, I gasped for air as if my heart had stopped, for I realized this was a part of the divine calling of God. Jehovah, who's my provider, had already made plans for me and everything was going to be fine. Storms are not always a bad thing. Sometimes our buildings have some structural defects and need to be addressed before they cause catastrophe future issues.

Months into my pregnancy, there was a season where there wasn't any food in the refrigerator. Here I was around Thanksgiving, pregnant and with two children to feed. Being in a place of desperation, caused me to fall on my knees, for I didn't want to ask my family for help. I was embarrassed, not wanting them to say my husband wasn't taking care of his responsibility. This was pride. Of course, my desire was to avoid the very thought of it coming to their minds. I remember crying out to God and reminding Him of His words (Peter 2:24). *Deuteronomy 28:1-14 states, "I am blessed going in and coming out" and He said He wouldn't give me serpent for fish" (Matthew 7:10).* Prayer was my way of remaining encouraged because I was so broken. Prayer also helped me to remember and trust that God is able. Matthew 6:25-26 tells us not to worry about what we will eat or drink.

After praying, I got up off my knees and my phone rang. It was a friend that I hadn't heard from in a couple of years; however, she's the godmother of my oldest son. She had contacted my mother to acquire my number. She said, "Let's go food shopping so we can catch up with the time we haven't seen each other." My immediate reaction after getting off the phone

was tears falling down my face. Abba showed me that He was indeed Jehovah-Jireh, my Provider. *"God will supply all our needs according to His riches in glory" (Philippians 4:19).* Life is so unpredictable; the Almighty will use whomever he deems fit to bless you. This young woman was of the Muslim faith, yet she was able to make herself available to be used as a blessing. In 1 Kings 17:2-16, Abba used a raven to feed Elijah at the brook. I had now experienced the scripture of faith being the substance of things hoped for and the evidence of things not yet seen (Hebrews 11:1). Abba Father was now taking me to another level to cast all my cares on Him because He cares for me (1 Peter 5:7).

My husband had now completed his training, so we finally had some funds coming into the home. This kept our head just above water. I was now coming into awareness of the strength of God *in me* – the One who divinely created me, has given me favor with Him and men.

The family survived through the trials and my husband was now a commercial driver, where he drove from state to state. One particular day while sitting home just meditating on God, my husband called me and said, "Honey I want to name our son Nehemiah." I didn't bother to ask him why, for this was enough to let me know he was reading the word of God. The divine calling of God does not require one's help, *because He knows the plans He has for us – plans of good with an expected end.*

Getting ready for another important part of my life, the doctors decided to induce my labor. My husband requested time off work, in order to be present in the delivery room; however, on the

day of delivering the baby, there was a bad snow storm. Highway I-81 was completely shut down and unfortunately my husband was stuck for over a day and a half and didn't make it home until three days after our son Nehemiah was born. Not long thereafter, my husband realized the need to be home – where he could wake up in the morning with his family and be present to raise his children. My better-half understood that God was in control of our lives and had now acknowledged Abba. He was now talking to his Heavenly Father, by making his request known unto God (Philippians 4:6). He had seen the undeniably greatness of God during the midst of the storm.

A few months later, his job had an open position in the state of New Jersey, which was only an hour away from home. The company asked him if he wanted to fill the position, since this would eliminate him being on the road, driving from state to state. He would now have the opportunity to come home every night. My better-half was excited to take the offer, even though it would require him commuting an hour every day to work. When a storm touches down in a certain vicinity, it can cause family separation for a moment; however, when the storm is over and the debris is no longer being tossed here and there, reflection takes place and causes one to appreciate what they have once reunited. That was exactly what happened to my family.

The birth of our son Nehemiah had now rebuilt our relationship. I no longer had the desire to give up on our relationship. My faith grew even more in Christ, now that my husband had acknowledged that God lives.

Chapter 8

Cultivating My Character
Through Discipline

◆

God began to cultivate my character of as it pertained to judgment towards others, giving me the understanding that pride is not of Him. The Bible states that, *"We should not judge by appearance, superficially and arrogantly, but judge fairly and righteously"* (John 7:24, KJV).

The divine calling of God is like being on the Potter's wheel. It systematically removes the unnecessary clay from the vessel and prepare it for display. Another part of Yahweh's way of building my character was where He allowed everything we had purchased with the unrighteous money began to malfunction – the cars; the vacuum broke; even the wedding ring which was purchased got lost. "Dishonest money dwindles away, but whoever gathers money little by little makes it grow" (*Proverbs 13:11*).

In this season, we no longer had two cars. The only transportation we possessed, my husband was in more of a demand to use it, traveling back and forth to work daily. My means of getting around was by public transportation. Yes, I was now taking the bus. This was another area of humbleness, as I hadn't ridden public transportation in many years. This was another part of God's divine process in my life. This season was

teaching me discipline and how to be grateful for everything God was currently doing in my household. Some days I cried walking in the cold, but then I would reflect on the single mothers with their babies in the strollers. Mind you, my status had changed from being a single mother; however, I had now experienced a portion of their struggles. It was obvious that I had encountered my teaching process of the divine calling of God. In fact, embracing this area of teaching birthed compassion in my heart for others.

My spirit had to trust God while going through His course, openly before everyone who knew me. Here I was, holding on to my faith in God. The spirit of pride wanted me to go into hiding, but this too was a preparation sequence which required me to remain standing. My vow to God was *"whatever my experiences were, I would share it as my testimony."* Elijah had to humble himself at the brook where the raven came to feed him bread and meat. He could have denied the food from the bird, especially a raven that eats dead things (1 Kings 17:6). How many of us would eat from a raven? Only a place of nothingness would cause us to even embrace the thought. The fact that Elijah could only depend on God while experiencing the trials of life, that he had no control over, his very mind was conformed to not deem his situation as a storm but as the Lord's perfect plan. Anything God allows to happen, trust and believe it's working out for His purpose and our good.

I decided to leave everything in the hands of God the Father who sent his only begotten son to die, that we might live.

This is where I had to prove Him now. If we were going to survive this financial deprivation, it would take dying to what I knew and embracing the wisdom of God. The affliction was necessary, for it brought me to my knees – a low place to seek my Father's face when everyone was fast asleep. Being ushered into His presence gave me confidence that Abba heard me. Yes!!! Although things might seem a bit topsy-turvy, no matter what, I must believe when no one else did. While going through my clay process, I learned that I had the power to speak things into existence and see the manifestation. The making process caused me to take authority over my life and the things that concerned my family.

Although my husband was working, it was tough to take care of all our expenses, such as making the mortgage payments on time every month. We fell behind a few months and had to find ways and means to stretch whatever funds we had to pay the rest of the bills. Regardless of the hardships, I was encouraged by persons whom God had placed around me, to stay alive in the time of uncertainty.

My faith led me to fast even the more, needing God's favor with our financial challenges. I uttered not a word of my request to anyone but to God and God alone. My spirit desired that God would let His miracles and power show evident that He's Jesus Christ – the same yesterday, today, and forever (Hebrews 13:8, KJV).

Faced with such major matter, crying out to God was my only avenue. The periods where the kids were in school, were the perfect moments to release my heart to He who said, "Come let us reason together" (Isaiah 1:18). Reasoning with Abba Father became my spiritual therapy, which helped to alleviate the pressures that stem from the cares of this world that is often overlooked. I began to have strong discernment that God wasn't finished with me yet, so whatever life lessons were in this for me to learn, I must embrace *the process* as a mother and a wife... especially a child of God. I trusted Abba Father who's in heaven, and fashioned the vessel, to make me "smile at the storm." I've learned this personally as my walk increased with the Lord, over the years.

A few months later we received a letter stating that our mortgage was paid in full! My husband was certain that the mortgage company had made a mistake by sending us the letter. I remained quiet, for this was the confidence I had in Yahweh (1 John 5:14-15). All things are possible with God. Esther (Hadassah) fasted and found favor with the king where he gave Esther her heart's desires, because she made her petition known amidst the odds being against her. Hannah was barren and desired to have a male child. She trusted her Heavenly Father and worshiped him without saying a word, where even the priest Eli perceived her to be drunk with wine. Although, Hannah's prayer was inward, she poured her soul out to the Lord. Not all prayers have to be heard by persons around you for it to be effective. Just as Hannah found grace in the sight of God and gave birth to a baby boy, I too found

grace in God's sight when my petitions were made before my Father concerning our family's monetary trials. The bible states that, *"But thou, when thou prayest, enter into thy closet, and when thou hast shut thy door, pray to thy Father which is in secret; and thy Father which seeth in secret shall reward thee openly"* (Matthew 6:6, KJV). Nothing is impossible for our Lord Jesus Christ and Savior.

Now that I understood that God was concerned with what happens to me, it was time to activate what the Teacher had taught me. A major final had now come for me to exercise what I had attained in the divine teaching of God. The only car we owned had reached its limit and stopped working. As a couple with a family, we knew having a vehicle was necessary. Stepping out on faith caused the situation to work in our favor. We financed a car and now had a payment every month. My better-half and I stepped out in faith once more and moved into another home with little to no furniture. My husband was hired with another company; his salary increased and was more beneficial to the family than with the previous job. The weight of our struggles became a little lighter. My prayer life shifted from wanting to be in Abba's presence to less praying because of comfortability with the new and welcomed light weight of life. How often we pray, and our Heavenly Father seizes the storm, and we forget about the fact that we should pray without ceasing. The bible states, *"Rejoice always, pray without ceasing, give thanks in all circumstances; for this is the will of God in Christ Jesus for you"* (1 Thessalonians 5:16-18, KJV). God has now reminded me of who He is, for the divine calling of God was upon my life.

Just like God reminded His people in times past, that He upholds all things in His hands. Abba Father specializes in miracles. Well, the two-year period had now arrived for my husband to do his D.O.T (Department of Transportation) test. He failed his physical due to (septal disorder) – a heart defect he had from birth; however, it was never a problem in the past with previous employment.

While out from active duties from his job and having to visit his cardiologist to sort out his health issues, he was terminated. This is even though his employer had told him he could've returned to full duty after the doctor gave the assurance that all was well with his health. Essentially, the company did not honor their words. During this process, I witnessed my husband break-down both physically and emotionally. Suddenly this birth defect was now a big deal and the cardiologist began to discuss the worse scenarios, as they often do. They discussed the option of a pacemaker if the worse scenario presented itself. When faith is tested, one has two options – to believe God's report or give into fear. The days seemed so long, and the nights felt restless from watching my husband's heart sadden. Anything having to do with the heart is of major concern – whether it be a broken heart, heart disease, or heart failure. It's enough to burden one with all the side effects that can cause other disasters. Moreover; my husband did not want to be categorized as disabled. His family was his biggest concern. Sitting on the sofa on the porch of my mother's home, I remembered him saying to me, "Who's going to take care of my family?" The enemy was placing an

ominous view in his spirit. Although I wasn't the actual individual with the health issue, I understood the concern he shared as a responsible, loving, and caring father and husband. My husband was the breadwinner for the home, so anything that affected him would trickle down to the entire family. He tried his best to balance his deepest of concerns where it wouldn't affect me, but even in his silence, discernment was at work where I could feel the unspoken words. Heaviness sat in the atmosphere, for there was a cross to pick up because I love Abba. Even the smiles seemed wired and restricted from the outbursts of gut laughter I was accustomed to." We both had different ways of dealing with this testing. There were moments in the night hours, where simply taking a drive for a breath of fresh air would be my antidote.

I remember driving and saying, "God, where are You?" Yes, I took time away from the family to cry out to Jehovah Paraclete, my Comforter when no one else was around. This gave me much peace. In this season of divine process, we lacked for absolutely nothing, for God was sending different individuals to be a blessing in every way one could imagine.

When life happens, and your natural man cannot apprehend the things that only your spiritual man has already apprehended, you find yourself clinging to the things which are conducive to the spirit. The divine calling of God pulled me away from my social life. He took away my desire to converse on the phone about frivolous and unnecessary topics. It became a little difficult to continue to assemble myself with

the saints at the ministry I was attending. My reason for the difficulties was me making sure my homely family duties were met, such as preparing all meals and a laundry of other things. Moreover, it would require me rushing for services. Every week making it out of the house on time for the gathering together was not working in my favor, and it didn't matter how much I planned a head of time. I just couldn't make it out of the house on time.

Sometimes God will halt us in the plight of our busy lives, for us to see and hear what He's saying in his divine seasons. The Almighty was working on me to birth something great out of this test, and so He wanted me by myself. If one was to see me through spiritual discerning, they would notice a big question sign on my forehead. Yes, I had questions. Many of them! I couldn't help but to reason with Abba about numerous things. Some saints say one should not question God, but I beg to differ. His word clearly states, *"Come let us reason together"* (Isaiah 1:18). For one to reason with another, there must be two parties talking to each other. *Reasoning means to think, understand, and form judgments by a process of logic.* During this process, there was a pull on my spirit to start teaching the word of God.

Now here I am teaching my immediate family at home, not realizing it was also the divine calling of God preparing me for His purpose. We began reading the bible together at least twice weekly and having Sunday morning devotions. Thereafter,

my husband had to do a follow-up visit with the doctor. We received some unwelcoming news, which brought him to a place of silence. There are different types of news that when they go through the ear, they bring joy, peace, and laughter, and then there are some that are designed to test your faith. In this particular case, the information given by the doctors came to rob us of the peace that existed in our home. The countenance on my husband's face was so obvious, and I couldn't wait to get home where I could fall at the feet of Jesus and make my request known unto Him (Philippians 4:6, 7).

The divine calling of God was taking me through diverse processes to test my God given roots. Upon entering the house, my immediate words to my husband was "I'm going to stay down stairs for a little." The sole thought that protruded through my mind was the "Abba Father who is in heaven prayer" (Matthew 6:9-14) because this was how He taught the disciples to pray. After praying this prayer, the story of Job dropped in my spirit while lying prostrate before God, which prompted me to say, "Though you slay us yet will we trust you." I stood firm on the word of God, while setting my affection above and surrounded myself with a positive atmosphere. One of the worst things we can do as a people while dealing with challenging circumstances, is to associate ourselves with negativity, selfish people, or persons of none or little faith, and the unspiritual critics. My focus was holding on to the word of God because faith comes by hearing and hearing of the word of God (Romans 10:17). I gained confidence in my spirit and heart that the "I Am that I Am" was going to work this test taking

process in our favor. *Selah*. Well, as time progressed, my husband did a minor health test to see if the issue would be a further hindrance to his health or required additional attention. Let's just say the next test that the doctors ran on him, resulted with no need for any major surgeries. My Jehovah Rapha is a healer!

Making it out of this season felt as if I had gone through a battle that took all the oil that was in my cup. Have you ever gone through a storm, where your victory would only come through trusting Abba with all your heart, even when no one understood whether it was a category one or five storm? Some storms are predictable, so we can prepare for them when they hit, but this one did not show any signs on the radar. Though it ended in victory, there was still a cleanup process. I couldn't help but to have questions on why the divine calling of God would put me through such a sudden test. This reminded me; God will not allow the temptation to be more than you can bear (1 Corinthians 10:13).

A few weeks later, my journey allowed me to encounter a woman of God who I'd met while my aunt and I were out and about. Shopping wasn't on my to-do-list; however, my spirit was pressed to enter this department store, for reasons I could not explain. Nevertheless, upon entering the department store I ran into a friend of the family. She was accompanied by a woman whom I'd never seen before. The woman looked at me and uttered "you don't even know who you are." Let's be honest, how often does someone walk up to a perfect stranger and tell

them they are not cognizant of who they are? Well, this too was a fragment of God's divine connection; the woman spoke to my spirit and not to my flesh. She confirmed what I felt in my spirit. Every question I had asked Abba that was unanswered, the Almighty used this lady to sum up every question.

The purpose for me entering the store was now evident because the areas of my life she tapped into weren't words I uttered or shared. My spirit bore witness that it was God. I even gained answers for some unspoken questions which were in my heart and spirit. Just that short moment in time, my spirit was encouraged by Abba's divine encounter.

One has to understand how important this divine meet up changed my views. This instrument of the Lord met me at a place where I was sick and tired of prophecies; I didn't want anybody to prophesy to me. I had a laundry bag of prophecy that were piled up in a bag, and on any given Christmas it would be enough prophecies to pass out to my entire neighborhood as gifts. These were all prophecies that didn't come to pass *as yet*. Too often we allow small mishaps or disappointments to discourage us from what our Heavenly Father is saying in His season. We must hold on to God's promises.

I had to gain understanding that when God speaks a word into your life or over your existence, you hold on to it. His word is "yeah and amen." It's not important how long ago the word was

given to you, don't disregard it and say it will never come to pass. Jehovah Rohi waits for the appointed time to bring His word to manifestation, that only His will be done on earth as it is in heaven. The word of God is designed to govern His sheep on earth. God is the Word and He stands by it. He gave Abraham His word, made a covenant with him, and told him that he shall be a father of many nations (Genesis 17:4, KJV). He told Abram that he will be exceedingly fruitful and make nations of him, and even kings shall come from his lineage (Genesis 17:6, KJV). Abraham was a hundred years old when he had Isaac – the promise child (Genesis 21:5, KJV). When a word is spoken over you, it must be tested.

Abraham took Isaac to be a sacrificial offering to God as he was instructed and when he arrived there, an angel said unto him, "Lay not thine hand upon the lad, neither do thou anything unto him: for now I know that thou fearest God, seeing thou hast not withheld thy son, thine only son from me (Genesis22:12). Simply put, Abraham had faith in God.

Admittedly, I was a little angry with God even though he had done many things for me that I wasn't worthy to receive. If we can be honest sometimes as humans we get to a place in our lives where we question who we are in God, and what our purpose is on the earth. Suddenly though peace was mine. Once again my Father had assured me that He was still with me, because He cannot deny His Word or Himself. My very existence was a word that was spoken. I am a product of "let there be" in Genesis one. Speaking with the woman of God had truly confirmed what I felt in my spirit. Every question I had asked God, He directed me right back to his divine purpose and plan.

Chapter 9

Confirming His Call on Your Life

◆

The divine calling of God will simultaneously confirm what He has placed in you while resurrecting His heavenly reason for placing us on earth. I'd now experienced the God w h o hears my cries and in fact knows the thoughts that He thinks towards me – thoughts which are good and has His perfect will attached. Abba Father has His divine and carefully orchestrated ways of bringing His chosen into what He predestined for their lives. With that said, a group of young ladies and I decided to start having prayer on Fridays simply to empower each other, as we desired to seek after the things of Christ. Our Heavenly Father does not force His plans and purposes on His creation, yet we ultimately end up doing His will as He allows the pressing process to direct His chosen to Him.

The coming together on Fridays was going rather well; in fact, other women were attending, and the group increased in numbers. I suddenly realized that the divine calling of God was calling me into leadership. Here I was feeling the need to seek the Lord Jesus' face more than ever, impressed upon me. Going through the crying process, reminded me of the weeping prophet Jeremiah. God was working on my inner-man for **His kingdom assignment**; therefore, the weeping process was a symbol of the flesh dying. The encounters began and I had visions of me soaring above the trees and seeing the tilled ground as far as my

eyes could see.

The call of God brought me to an unfamiliar place in my journey where I had on no occasion been before, but in my heart, it felt perfectly right for my spirit. The lives of the women who were attending the prayer were transforming before my very eyes – getting filled with Abba's Holy Spirit and speaking in their heavenly language, and growing spiritually in Christ. My season of divine purpose had now come, even though giving God "all of me" wasn't something I sat and planned out. Please be mindful that I wasn't a part of anyone's ministry at this point. Abba was working on me in the secret place of the Most High, where nobody could take the credit for molding and fashioning what He had already perfected before the foundation of the earth. The divine calling of God taught me how to love despite how friends, loved ones, and strangers alike treated me. It is our job to owe no man anything but love (Romans 13:8-10).

One day, I made the decision to visit someone's building to assemble myself. If you noticed, I said building and not church, for I am the church. In any event, an associate of mine spoke well of this ministry, which prompted me to visit. As I made my way through the door and into the building, a woman with a distinctive voice projected words saying, "Yes, your time has come! It's time for you to walk in leadership..." This was the same lady I had met over a year prior in the department store. Once again, the divine calling of God will give you understanding *in due season*. The calling of God had brought me to a place where His yes became my yes, and his will was now my will.

The divine calling of God has brought my better-half to a place where he opened his heart to Christ. I watched as God molded him for the preparation of the next chapter of His plans and purpose for his life in him. I love that Abba prepares us for

where we are going. When others see you out of season, they aren't able to fully comprehend it all as they haven't seen the full purpose of the tree. One cannot run from the divine calling of God unless he or she desires to become a junk product.

For example, when a buyer purchases a car and the vehicle does not perform as it should, the owner's most sensible option is to junk the car because there is no reason to continue pouring into something or someone who has no desire to perform its required duties. We are bought with a price and though many are called, only few are chosen. I later learned that everything I did not like or wanted to have anything to do with, were the very things that Abba would use to mold me.

Even though though I was from Jamaica, I wasn't fond of Jamaicans. Most of my life was amongst Americans seeing that I migrated to the United States, at a very young age. I didn't want to associate myself with the ways in which my mom dealt with situations. This reminded me of Moses. He was not an Egyptian, but God separated him from his own culture from birth, so that he would not have the same mindset as them. Moses was called to lead his people out of bondage. Bondage can be a mindset that has a generation stuck a place; however, the divine calling of God gave me clarity of why I was set apart from my culture for years. Abba wanted me to be familiar with the history and behavior yet teach me to have a different mindset on how to deal with things and people.

The very things that we dislike are oftentimes the very arena that Abba uses to bring changes. There were still areas of love that God had to develop in me, such as showing affection towards the women from my Jamaican culture. My perception

was of them being magnetically connected to attracting drama in atmospheres with some type of animosity always following them. My opinion of the men was of them being very aggressive and quick to lay their hands on the weaker vessel.

Again, this was my perception. The thought of dealing with them most likely meant having to interacting with their mothers, which would mean dealing with cultural behaviors that I had no desire being a partaker of, much less be connected to. Be careful of the things you dislike, for it's probably the very thing Abba will implement to bring changes within a group of people. The enemy understands that God has a plan for you and His people, so he tries to discourage our early experiences that we might abort our purpose.

It is obvious that the devourer understands that once we get a grip of our purpose, destiny, and how effective we will become in the kingdom of God, he himself fears the God in us. Know that we are overcomers and what the enemy designed to kill in you, will always work out for your good! What we experience is not merely just for us but instead to share with others so that they may overcome by your very testimony.

The entire summation of the whole matter is that I didn't really care too much about Jamaicans, even though I'm a native. It is so amazing how God opens ones understanding to His will. Here I was ignorantly looking at a field of trees and judging their outer appearance because I didn't understand purpose.

Moving forward, our all so sovereign God used a group of young ladies from Jamaican to teach me how to extend *true love*. I even married into a Jamaican family. *Abba is quite humorous and seemed to have set me up – of course in a great way.*

Seeing things in a different light as Abba removed the scales from my eyes caused me to think once again about the life of Moses and the groups of people he was amongst. They were a stiff-necked and rebellious set of people, yet God favored them and sent Moses back to Egypt to bring them out of bondage. Abba unveils His secrets to the ones whom He loves and trusts to do His will. Which brings me to say, the next time you feel great dislike for someone or something, ask yourself "Why do you feel this way? What is the reason for the negative perception? Do I have any connection to this very thing or person? How can I grow from the very thing or person I dislike?" In the process, you will find that the very thing you are afraid of or have dislike for, therein lies a lesson laying subtly – that can be missed if one allows pride to get the best of his spirit.

The key to the divine calling of God are submission, humbleness, and trusting Him – for He knows the plans He has for you, plans of good and not of evil and promises to give you an expected end. David trusted the very One who anointed him. The divine calling of God will take you through storms that your natural man cannot comprehend; however, your spiritual man will take full control because when your earthly being is weak, the Almighty is strong (2 Corinthians 12:10).

Now Abba was ready to test another area in His vessel – to prepare it for the ultimate purpose. Yes, being divinely chosen has everything to do with *purpose*. Every seed that is planted has a purpose to fulfill on the earth. The same way He

volunteered Job to be tested by the enemy (Job 1:1). This is where the seed gives total will and every response should be lined up with the perfect will of its Creator by saying" *Thy Kingdom Come Thy will be done" (Matthew 6:10)*. Purpose does not have room for excuses. The fig tree was out of season when Jesus was hungry, and so He cursed it because the tree had everything it needed to bear fruit yet bore absolutely none (Mark 11:12-25).

The divine calling of God will put you through processes that cause feelings of loneliness. The very people around you will want to stone you, just like David experienced in 1Samuel 30:6. The divine calling of God will bring you to a place of testing where you would prefer to get into the presence of God for yourself and tell Him what is really in your heart. At times when we are amongst people, we tend to pray in a way that is politically correct, but when the storms in our lives rage and the debris, coupled with the wind, begin to hit and toss us, we will do whatever it takes to survive. The divine calling of God will take you through a number of seasons, where the tears will roll; however, there's no time for a perfect and scripted prayer so words will form itself out of your belly. Whatever you are feeling deep within, is the very thing that will come to surface. This is what I call the place of unrehearsed worship. The bible said He collects all our tears in a bottle (Psalms 56:8), so when Abba pours it out, not one word or punctuation is missing from what we silently express with our tears.

Chapter 10

Accepting Your Assignment
When It Seems Impossible

◆

The divine calling of God will allow edges to come down occasionally just to get your attention and remind you that you are not of your own (1 Corinthians 6:19-20), where you become willing to accept your divine assignment...even when it seems impossible.

Accepting the assignment reminded me that everything is simply about Abba Father being glorified through our lives. When I think of His will, flesh has no place in this realm because our natural being does not have what it takes to withstand the enemy. However, He who lives and lives forevermore has already withstood the assignment at the cross. *Colossian 2:15 states, "He has nailed principalities and powers and made a public spectacle of them, triumphing over them in it" (KJV).* Ezekiel was a good example. He accepted his assignment. Yes, the Ezekiel season had come for purpose to manifest itself, so when Jesus asked the question "Can these dry bones live?" Ezekiel took on the mind of Christ and responded, *"Sovereign Lord you alone know" (Ezekiel 37:3).* Flesh had no place in the conversation because it was now God talking to His own image, His spirit, Himself, and His image answered through His vessel *because God does not deal with the*

flesh. The spirit of God in Ezekiel came forth and answered. In fact, the bible states that *"those in the flesh cannot please God" (Romans 8:8).*

The divine calling of God requires your will to be His will, which requires one to walk with humility and kingdom authority. There are areas of our lives that He tells us to prophesy to things that once seemed dry – you know the dry bones. Yes, basically anything that seems dead. Everything that was dead in me was now coming together. My spirit became bold, where the fear of what life had to offer was no longer present. I saw myself as being fearfully and wonderfully made, as stated in Psalms 139:1. The very things which seemed impossible became possible through the spirit of God on earth in me. Acceptance of the divine assignment of God reminded me of His creation David. Without the touch of God and giving total will, I would have accepted the words which were designed to wound and leave me as the dry bones in a valley. *In Psalms 104: 29-30 David stated, "Thou hidest thy face, they are troubled: thou takest away their breath, they die, and return to their dust. Thou sendest forth thy spirit, they are created: and thou renewest the face of the earth"* (KJV).

The divine calling of God confirms that anything He's assigned you to, He'd already fashioned it into being. Perhaps the mistake those of us who are called make is keeping Abba in a box due to the finiteness of our human status. Accepting the assignment requires accountability, where the will of God rejects the spirit of fear; He then gives utterance to open our mouths and

speak to what He has already created. God is sovereign, so everything must respond to Him. Our Abba Father said, *"Let there be light, and light appeared on the earth, because He is the way, the truth, and the life"* (John 14:16). The word of God became flesh and dwelt among His people, so He uses His word to bring manifestations on the earth through the vessels that He divinely calls. *According to Isaiah 55:11, "So shall my word be that goes forth out of My mouth: it shall not return on to me void, but it shall accomplish that which I please, and it shall prosper in the thing where I sent it (KJV).* I had a responsibility as God's chosen ambassador.

The divine calling of God is not lukewarm; it's either hot or cold. It will thrust you into God's authoritative purpose, propelling you to speak the word of God, which is our daily bread. The word of God gives life the same way he told Ezekiel to prophesy to the bones that were dry, where immediately flesh came up on them. This is the same way God speaks to his vessel for His intent and manifestations.

So now everything pertaining to your natural existence that was seemingly impossible must now accept possibilities in God. As a result, the Spirit of the Lord begins to give revelations to His divine vessels, of what He's going to establish on the earth. The natural man looks at what "seems to be" while the Spirit of God reacts to "what is" because Abba is the word. I had to learn speedily that accepting your kingdom assignment brings much opposition. I had to face the doubters because a prophet has no honor in his own country.

David accepted his assignment; however, the problem

was that the people around him didn't recognize the spirit of God upon His life. Yes, the divine calling of God will bring revelations that your associates, friends, and family members will only give awareness to your natural existence. It's imperative that one has understanding when they're called away from the caterpillar formation. Moreover, the ones who are led by the spirit into their process must embrace that preparation has come for them to be transformed into a beautiful butterfly. The butterfly can no longer take on the mindset a caterpillar. Transformation broadens coasts and territories. When you go back to the ground with the caterpillar, it's no wonder they will not recognize the Christ in you...because after all, you've been transformed from what they are accustomed to. Also, the fragile creation makes them a threat and enemy because you don't look the same.

David was divinely anointed and predestined for the assignment and purpose of the goliath era. Any assignment you are divinely called to, you are already fully equipped to triumph. In 1 Samuel 17, the Philistines challenged Israel to send their best man to fight Goliath. The people of God were now faced with the kingdom of darkness coming up against the kingdom of heaven. Saul and his army, including David's brothers were focusing on the outer and their natural strengths and abilities, such as, what the enemies looked like, yet no one had confronted the assignment. Each child that is called from the matrix of his mother's womb has a mandate to fulfill their purpose for the kingdom of heaven. Most importantly, we must be

able to discern and differentiate which assignment is ours and which is not. David was quite aware of his purpose. He ran from Saul, yet ran head-on into his Goliath assignment. The divine calling of God is for our Abba Father to bring His original intent from the kingdom of heaven to earth.

Chapter 11

Coming into Kingdom Understanding

◆

The spirit of the Lord took me by myself and began to teach me. I often tell people that I am an Ezekiel 34 seed because what I've learned, Abba taught me in the confines of my home. The Spirit of the Lord began to give me understanding about the kingdom. In the kingdom there's no room for religion; it brings separation. In the kingdom of God, we are one, as the Father and the Son are one. A key concept that I had to recognize as my mind was being renewed, was that the kingdom is not selfish, and maturity comes through the governing of the word of God. The kingdom requires spiritual maturity, where we must be selfless and embrace the needs of others. Our Heavenly Father has deep concern for His citizens. *1 John 17:9 states, "I pray for them: I pray not for the world, but for thine which Thou has given Me, for they are Thine" (KJV).* The Bible also states in John 3:16 that, *"For God so loved the world that he gave His only begotten son that whosoever believes it in Him should not perish but have everlasting life" (KJV).*

We must see ourselves as one body in the kingdom of God. *According to John 17:19-23, "And for their sakes I sanctify myself, that they also might be sanctified through the truth. Neither pray I for these alone, but for them also which shall believe on me through their word; That they all may be one; as thou, Father, art in me, and I in*

thee, that they also may be one in us: that the world may believe that thou hast sent me. And the glory which thou gavest me I have given them; that they may be one, even as we are one: I in them, and thou in me, that they may be made perfect in one; and that the world may know that thou hast sent me, and hast loved them, as thou hast loved me. (KJV)."

The divine calling of God gave me better understanding that principles and unity are key attributes in the kingdom of heaven. I counted it joy to esteem others above myself, for it was not a struggle to honor another citizen's gifts and calling. Philippians 2:1-3 makes it clear that *"If there be therefore any consolation in Christ, if any comfort of love, if any fellowship of the Spirit, if any bowels and mercies, fulfil ye my joy, that ye be likeminded, having the same love, being of one accord, of one mind. Let nothing be done through strife or vainglory; but in lowliness of mind let each esteem other better than themselves (KJV)."* That defined: it is the will of God to bring you to take on the mindset that was also in Christ Jesus. Who being in the form of God thought it not robbery to be equal with God (Philippians 2:5-6).

The divine calling of God demonstrates to me that as a body we need each part to accept its worth and operate in its full potential in the kingdom of God. For example, when you tell a child that they are doing a good job, the child becomes confident and they are more willing to complete any task given to them. The child no longer feels out of place or of no worth, because you are now building their skills by acknowledging

and congratulating his performance. In addition, the parent or teacher now bears witness that the child understands his ability and worth. The parent or teacher also distinguishes that their method of teaching works. As a result, the parent or teacher recognizes that their purpose in the field they are called to is beneficial to others. Peter was a very interesting disciple in the Bible. He was approaching the purpose of the kingdom with a fleshly mindset.

The divine calling of God gave me understanding that one cannot operate impulsively because their flesh will cause them to operate outside of the purpose and will of God. *John 18:10-11 shared that "Simon Peter having a sword drew it, and smote the high priest's servant, and cut off his right ear. The servant's name was Malchus. Then said Jesus unto Peter, put up thy sword into the sheath: the cup which my Father hath given me, shall I not drink it? (KJV)."* The divine call of God eliminates the "why me Lord" attitude and tells you to pick up your cross and carry it.

When I think about Peter's reaction to the kingdom's purpose, it was in an immature way though he was also the same one who revealed that Jesus was Christ, Son of the living God because he was in tune with the kingdom of heaven. Jesus, who was spiritually mature, valued the disciples over Himself. Because in Joh 18:8 Jesus answered, "I have told you that I am He. Therefore, if you seek Me let these go their away." Jesus knew the disciples were a part of the kingdom purpose – to go forth and preach the gospel on earth after He was crucified.

Abba Father began to teach me that spiritual maturity

causes one to acknowledge their issues in areas where they've fallen short or have a weakness. Again, spiritual maturity is not selfish and requires persons to consider others above themselves. For example, Peter was more concerned with saving himself, so he denied Jesus by saying I know him not (Luke 22:54-57, KJV). As I evaluated myself in my early encounters with Christ, my actions were self-centered against the call of God, which reminded me of Peter in Luke 22:61-62. Peter's selfish act was revealed to him and caused him to weep bitterly. He had to deal with himself because the word of God is yeah and amen. Christ told him that he would have denied Him when the cock crew three times. Spiritual maturity reveals one's kingdom assignment and purpose. The king who governs a people makes it clear to his citizens what is required of them as ambassadors. Coming into kingdom understanding eliminates ignorance of their identity and what they are divinely called to do, so God now makes it known to them as He did with David. Immaturity will hinder you from the original intent of God for your life. We cannot incubate ourselves in the spirit of denial, by not wanting to approach our assignment, or deal with the purpose head on. Peter was charged to feed God's sheep. After the denial process of Jesus, Jesus asked Simon Peter three times, *"Simon, son of Jonas, lovest thou me more than these?"* Peter responded, *"Yea, Lord, thou knowest that I love thee." Jesus said unto him, "Feed My lambs (John 21:15, KJV)."* Peter became grieved in the spirit because he was asked the same question three times. Abba Father asked the same questions more than once, so that our spiritual man may come into agreement with understanding the kingdom

assignment.

The divine calling of God will bring you through a number of testing processes in order to bring forth manifestation of His plans for your life. I no longer saw myself in the flesh, even though the vessel which I occupied is earthly. My mind had been transformed with full understanding, that I'm a kingdom resident who's been given a language to communicate with my Heavenly Father – *that His kingdom come, his will be done.* As a resident from the kingdom, I could now stand boldly and declare the word of the Lord: *"Again I say unto you, that if two of you shall agree on earth as touching anything that they shall ask, it shall be done for them of my Father which is in heaven" (Matthew 18:19).*

Peter who was called the rock, *(for upon this Rock I build my church and the gates of Hades shall not prevail),* understood his purpose and in Acts 2:14 he stood up with eleven disciples, and lifted up his voice and said onto them, "Men of Judaea, and all ye that dwell at Jerusalem, be this known unto you, and harken to my words" (KJV). Spiritual maturity will allow you to walk in power and authority just as Jesus Christ did when he was on the earth. Peter began to operate in the same healing power as Jesus Christ. The bible states that a certain man lame from his mother's womb was carried and laid daily at the gate of the temple called Beautiful, to ask alms of them that entered into the temple: Peter fastened his eyes upon this lame man, told him to look on them, took him by the right hand, and lifted him up. Immediately his feet and ankle bones received strength! This is the same power that Abba Father has given us when he

said greater works we shall do on this earth.

The divine calling of God brings about spiritual maturity that eliminate fleshly characteristics such as adultery, fornication, uncleanliness, lasciviousness, idolatry, witchcraft, hatred, variance, ambulation, wrath, strife, sedition, heresies, envying, murder, drunkenness, and reveling; for these characteristics cause one not to inherit the kingdom of God (Galatians 5:19-21). In contrast, spiritual maturity allows kingdom citizens to live according to the fruits of the Spirit, which are love, joy, peace, long-suffering, kindness, goodness, fruitfulness, gentleness, and self-control.

Chapter 12

The Kingdom of God Being Tested in You

◆

The divine calling of God will strip you from what you think you know, and thrust you to a place of taking on the mind of Christ. There's a process that is necessary for the chosen to experience...just as He did with Job. The earthly things that we've attained or persons we are connected to, does not depict our worth or strength. The bible stated in Job 1:8 that "He was a blameless and upright man – one who feared God with reverence and abstained and turned away from evil...because he honored God (AMP)." Job was well respected, and said to be the wealthiest man of the east (North Arabia), so he had no reason to curse God because he was experiencing life without challenges. The divine calling of God tests you in every area, such as your help, children, financial status, health, and friends. The hedges were taken down from every area that the enemy thought would bring Job to the place of cursing God. What's amazing about the testing process is, He who divinely calls us does not deal with the flesh and does not defend the fleshly nature of man. The enemy had access to test us on the earthly and tangible things, but what belongs to God was off limits – *the*

soul.

The divine calling of God brings about the process that will let the light of God shine through His vessels. Our spirits and souls belong to God because He's the life, and He cannot give access of who He is to the deceiver. In other words, He would be giving the enemy control over his existence. Abba trusted His divinity in Job that He would not curse Himself, which was in the vessel being transformed into pure gold. God who calls the chosen has already won, for He gave His son Jesus Christ to be a sacrifice for His people on the cross. *Remember no man took his life, but He laid it down.* The Christ in Job – the Spirit which is not from this world, was far from cursing the divine purpose, designed to bring manifestation to life on the earth. It's the Christ in us that He wants man to see, the pure gold that is tried through the fire, the heart of God that propels us to pray for those who mistreat us and say all manner of things about us...just as Jesus Christ experienced earth.

Gold has worth and the weight of the gold tells the value. There are seasons when the price of gold increases and others when it's at a flat rate. The pressing process of the divine call might be via financial testing, family challenges, or ailments in our physical bodies, but know that the pure gold which is Christ's will has already won. The word of God states that, *"But He knoweth the way that I take; when He hath tried me, I shall come forth as gold (Job 23:10, KJV).* The word of God also states, *"I have given unto them the words which thou gavest me; and they have*

received them, and have known surely that I came out from thee, and they have believed that thou didst send me. I pray for them: I pray not for the world, but for them which thou hast given me; for they are thine" (John 17:8-9, KJV).

The divine calling of God brought me through a process where I had to see God for everything more than I ever did before. Suddenly sickness came upon me that was supernatural. I can imagine how Job felt when the devourer went in and said to God that he wanted skin for skin, after he had tested Job with his helpers, livestock, and children; suddenly, he had boils from the crown of his head down to the soles of his feet (Job 2:4-7, KJV). Here I was, having lost my ability to walk, my body swelling, and things I was once able to do without a thought now became immensely challenging, where I had to now think about it before moving my limbs. Jesus Christ came that the lame would walk and the blind could see.

Every prescription and drug that the doctors were prescribing to help me, I was that one percent who had an allergic reaction. Now here I was going in and out of the hospital, back-and-forth to the doctors' offices...doing all types of tests such as spinal tap Magnetic Resonance Imaging (MRI), Computed, Axial Tomography (CAT scan), and X-rays. The doctors concluded that I might have traits of MS or transverse myelitis. "Multiple sclerosis, or MS, is a long-lasting disease that can affect your brain, spinal cord, and the optic nerves in your eyes" (WebMed, 2018). It can cause problems with vision, balance,

muscle control, and other basic body functions. WebMed stated that the effects are often different for everyone who has the disease (2018). Some people have mild symptoms and don't need treatment while others will have trouble getting around and doing daily tasks. I felt helpless; I knew that my carnal mind could not apprehend that which I'd already apprehended was happening to me. Rejecting all prescriptions, my medication became the word of God; it was now my daily bread.

Speaking healing to my bones, cells, and joints was the pill I took every day. Through this entire process I never complained because I knew that my Abba Father was doing something in me that was supernatural, to get my mindset to where He needed it to be. One day lying in the bed I remember saying to God, "I am at my Red Sea and if You don't open it up, then nothing can be done for me." Reminding God that He said, "His Word was made flesh and dwelt amongst me, and that whatsoever I bind on earth is bound in heaven, whatsoever I loose in heaven is loosed on earth, and by his stripes I am healed." Watching my children and family losing their faith, I looked at the right side of my body and spoke the word of God to it and said, **"NOW...FEET...WALK!"** Hallelujah! Hallelujah! Hallelujah! I was able to walk in the market again and pick up groceries, but the greatest thing about this process that I had to go through was a transformed mind and true introduction to the kingdom of heaven. You know that same kingdom of heaven that Jesus Christ said *"the kingdom of heaven is at hand."* This process changed the very way I prayed, as scriptures became life in me...which is Christ. I now tapped into the original intent of the things in the kingdom of God.

Chapter 13

The Divine Call of God Teaches You How to Pray

◆

The "Abba Father" prayer was given to govern us on earth. We oftentimes take the "Abba Father" prayer so lightly. It's important to gain understanding through seeking the face of God and coming into factual relationship with Christ that we too may receive revelation of what Jesus said to the disciples as to how to pray. *"Our Father which art in heaven, Hallowed be thy name. Thy kingdom come: Thy will be done in earth, as it is in heaven. Give us this day our daily bread. And forgive us our debts, as we forgive our debtors. And lead us not into temptation, but deliver us from evil: For thine is the kingdom, and the power, and the glory, forever. Amen (Matthew 6:9-13).*

The "Abba Father" prayer governs us on earth. Many times we say we know how to pray but unfortunately we end up praying amiss. The bible says, *"And when you come before God, don't turn that into a theatrical production either. All these people making a regular show out of their prayers, hoping for stardom! Do you think God sits in a box seat?" (Matt 6:5 MSG).* The KJV refers to them as hypocrites.

"The world is full of so-called prayer warriors who are prayer-ignorant". *They're full of formulas and programs and advice,*

peddling techniques for getting what you want from God. Don't fall for that nonsense. This is your Father you are dealing with, and he knows better than you what you need. With a God like this loving you, you can pray very simply.

Like this:

Our Father in heaven,

Reveal who you are.

Set the world right;

Do what's best—as above, so below.

Keep us alive with three square meals.

Keep us forgiven with you and forgiving others.

Keep us safe from ourselves and the Devil.

You're in charge!

The Divine Calling of God

You can do anything you want!

You're ablaze in beauty!

Yes. Yes. Yes. (Matt 6:7-13 MSG).

One probably would ask what it means to govern. The Merriam-Webster dictionary states that to govern is to exercise continuous sovereign authority or influence how one should conduct themselves in a kingdom or country. Coming into the kingdom of God, there must be an act of sacrifice. Sacrifice is the slaughter or the suffering of a person or an animal; an act of giving

up something valuable for the sake of something else which is more important; Christ offered Himself (Luke 22:15-16). *"For God so loved the world that He gave His only begotten son that who so ever believes in him should not perish but have everlasting life"* *(John 3:16).* When I think about the word slaughter, it is the killing of someone in a violent way. They beat Christ, pierced Him, put a crown of thorns on His head, and even pierced His side after He was dead (John 19:2, 29, 34).

The divine calling of God causes one to voluntarily go to the cross or pick up his cross and carry it (John 16:24). This was where Jesus was telling His disciples that if any man should come after Me, let him deny himself, take up his cross, and carry it. This is why I never complained when I began to go through that sudden bout of sickness; I had to deny my fleshly feelings and give God the glory. *According to Luke 22:42, "When the hour had come, Jesus went to the Mount of Olives and prayed saying, 'Father, if thou be willing, remove this cup from me: nevertheless, not my will, but thine, be done'".*

Sacrifice brings about a death in the flesh – the natural man. The divine calling of God allows the test to surpass the natural understanding, so that our Heavenly Father can take full control of our spirit. Reason being, the kingdom of God does not deal with or accommodate the flesh...at all. In fact, Romans 8:5-10 puts it this way...it is impossible to please God with the flesh. I must say, this process brought me into full acceptance of God's original intent, which is His kingdom being manifested

on earth. Jesus Christ had to suffer persecution, so the ones whom He has chosen must also share in His sufferings. *"Blessed are those who are persecuted for righteousness sake, for theirs is the kingdom of heaven"* (Matthew 5:10).

While going through this ordeal, Abba Father began to speak to me and give me understanding. The enemy is not after you; he's after the kingdom of heaven which is in you. The enemy knows that God does not deal with the flesh because *they that worship him must worship in spirit and in truth.* Again, he's not concerned about you; he's after the kingdom of God that you house!

Because the enemy is after the kingdom of God in you, everything connected to your kingdom assignment is now at risk. John the Baptist, who baptized Jesus, had to suffer simply because he was connected to the kingdom. His season came to fulfill the peak of his kingdom assignment, where it was made known that Jesus was God's beloved son. Not long after, John the Baptist was now facing persecution, was placed in prison, and later beheaded (Matthew 3:16-17). Whenever you're at the peak or in the season where God wants to bring His manifestation through you on earth, you begin to face persecution. It is actually amplified. Jesus Christ heard about John the Baptist and immediately he began to preach, "The kingdom of God is at hand!" Abba was revealing to me that the kingdom of God is connected to my purpose.

The divine calling of God brought me to understand the purpose and my identity in the kingdom. Abba knew that I was ready to take on the whole armor of God through the process of sickness. I knew in my spirit that the experience that I had to face was supernatural. I had just returned to the US after going to Jamaica for ministry. I returned in my full health and suddenly my entire mobility changed. *"We wrestle not against flesh and blood, but against principalities, against powers, against the rulers of darkness of this world, against spiritual wickedness in high places. Wherefore, take on to you the whole armor of God, that ye may be able to withstand in the evil day, and having done all, to stand" (Ephesians 6:13).* Be not fooled; the enemy is very aware of your connection to God and His purpose in you. Peter had the ability to tap into the kingdom of heaven. He knew the voice of God; therefore, the kingdom assignment on Peter's life (God) was at hand. The Lord said to him, *"Simon, indeed Satan has asked that he may sift you as wheat, but I prayed for you, that your faith should not fail, and when you have returned to me, strengthen your brothers" (Luke 22:31-32).* Satan is after the kingdom of God in us, *especially* when you can hear the voice of God. Jesus asked the disciples, *"Who do people say the Son of Man is?" It was Peter who replied, "You are the Messiah, Son of the living God" (Matthew 16:16).*

There are benefits to being able to hear the voice of God for yourself. *Jesus told Peter, "Blessed are you Simon Peter, for this was not revealed to you by flesh and blood, but by my Father in heaven. On this rock I build my church, and the gates of hell will not overcome it" (Matthew 16: 17-18).*

When you have the ability to hear God's voice the gates of hell cannot prevail. All it takes is one word to be spoken in the atmosphere for you to hold onto. When your Heavenly Father speaks, have faith and trust in Him. Whatever comes up against you shall not prevail. Therefore, the enemy cannot hold you hostage to anything he presents before you or is allowed to put you through.

Moreover, the name SHEE-MONE in the Hebrew is Kefa: which means a rock small enough to be lifted with one hand...so Peter who was built on a rock which was the church that came by way of a revelation that had already deemed him an overcomer. Peter was the rock and God made man in his own image. In other words Peter became a chip off the block. God is a spirit and we are not of this world; we are spiritual beings in earthly vessels. The divine calling of God knows everything about you before you were conformed in your mother's womb (Jeremiah 1:5). Peter had the ability to hear God; however, he was also the one who conformed to *works* and *laws* and turned away from grace and faith – the Judaism law of circumcision.

God is so awesome that when *the called* drifts or falls short, He will raise up someone who can speak directly to their spirit, to bring correction and remind them of His original intent and purpose for their lives. The divine calling of God brings conviction and correction to the ones that He loves, just as there was a Nathan for David, a Samuel for Saul, and a Paul for Peter. God rose up Paul to say, *"Foolish Galatians, who bewitched you that you should not obey the truth, before who's eyes Jesus Christ had been evidently said fort, crucified among you"* (Galatians 3:1-5,

KJV). The divine calling of God brings you into "thy kingdom come, thy will be done" where your spiritual man cannot feel comfortable out of the will of God. It's in Him that we live, move, and have our being. As some of our own predecessors have said, "We are His offspring" (Act 17:28 NIV).

The divine calling of God requires totally surrender, where it's no longer you but the Christ in you. Taking on the mind of Christ, walking in the supernatural, and trusting that He who called you...will keep you from falling.

Chapter 14

The Agape Love Birthed Unconditional Love for My Husband

◆

I remember having an experience not too long ago where my hubby and I went out to a formal gathering and I misunderstood his intention towards another female. I became bitter because of his lack of acknowledgment when I tried to correct him regarding his behavior. Having left the event, all the anger was boiling over in my spirit – to the point where I had an outburst of emotions that led to me getting very confrontational. Uttering quite a few choice words, telling him that he was disrespectful and saying to him "Please don't pull me out!" Trust and believe that if you ever think that you're flawless, He who created you will wait for that perfect moment in order to demonstrate the areas in your life that need work. Abba waits for that perfect opportunity to chip away the excessive clay on the vessel before it is placed on the shelf.

Through a simple argument, bitterness and anger were birthed. I simply felt disrespected. As I sat by myself in reflection I was really curious to figure out what made me so angry towards my husband? I was now a ready and willing participant to deal with the truth of what transpired, breaking down into tears and telling God I needed his help. I needed Him to come in and bring clarity. I desperately waited for God to show up with His

truth, amidst the chaos I was now experiencing on the home front...as it pertained to the state of *my* heart. Anger and bitterness were already taking root when I received a call from a sister in the faith who began to tell me that she saw my heart bitter as they were praying for me. This was followed by a letter from a brother who shared some revelations the Lord laid on his heart to relay to me. Every word given was so perfectly timely and relevant. The bulbs lit up and I could now see clearly *that whom I was bitter against was innocent and the accuser had crept in.* My past from twenty-four years ago had revisited me, stemming from my first child's father. I had never dealt with the pain of that relationship and because I was now ready to love and embrace the will of God, this was the perfect time to highlight the dormant issues. Weeping with open rebuke while feeling convicted of my previous actions, I remembered telling my husband I was sorry and that I was housing something that was never confronted over two decades ago, but that I was now ready to deal with it and let it go. What the enemy meant for bad, God will turn it around for our good!

After all these years, it was no longer only a glimpse into the true love of God, but instead having a willing heart to experience the unknown without hesitation. This is the most rewarding fruit to eat of as well as share with others. The Agape love is so powerful because it destroys enmity, strife, rejections, selfishness, control, manipulation, and un-forgiveness. The true love of God heals wounds, reconciles, removes boundaries such as bringing down walls we've created, and gives a new meaning of what it is to live in God – a brand new life! We're so oftentimes

caught up with being in love with another. Firstly, being in love starts with your Maker who lives in you! If He lives in you, then what comes out of you to your spouse, parents, children, siblings, and friends will ultimately be the true love which lives in you. *"As we think in our hearts, so are we"* (*Proverbs 23:7, KJV*). In fact, taking on the mind of God transforms our hearts, convicts us, and produces unconditional love. The divine calling of God makes you vulnerable. It strips you swiftly away from all your Jericho fortifications (walls) – the fears of trusting someone else with something so fragile, such as your heart.

The divine calling of God takes you out of hiding and brings you into His true love...what He originally placed in us from a child. *The Bible states, "He called a little child to him, and placed the child among them. And He said: Truly I tell you, unless you change and become like little children, you will never enter the kingdom of heaven. Therefore, whoever takes the lowly position of this child is the greatest in the kingdom of heaven"* (*Matthew 18:2-4, NIV*). When you were a child and someone did some type of wrong to you or treated you unfairly – whether it was a relative or friend, holding a grudge was never a thought. We more readily continued to love them despite the negative interaction. Another example, when your parents give you a spanking, you found yourself returning to them with pure love moments later.

This is an illustration of the original intent relating to love from the Heavenly Father – untainted at such tender age. The attributes of a child humbles and prompts you to express love regardless of how you are handled. My husband was loving me unconditionally, but I couldn't see it because my heart was nicely

tucked away. The divine calling of God will expose you first to your own self but if you ignore the signs willfully, then others will begin to see your naked spirit.

Finally, after all these years tucking my heart away from others and dealing with them from behind a wall, here I was with the full understanding of what God wanted to show me. The true love of God does not need us to fight, pretend, or protect ourselves from another individual. If Jehovah lives fully in your heart, then all those positions is His to set in order. I know taking on the heart of flesh causes one to feel versus live in numbness. If I put some dough or clay in my hands and I press a stone in it, what do you think will happen? Retracting the stone from the dough or clay, you'll quickly observe that the stone rips a piece of the element. When you rid the stony heart and take on the heart of flesh, you will indeed feel, but most importantly, you'll begin to learn how to love the pain away. Now finally free from speculations as you take a moment to just smile. No longer ignorant of the enemy's devices (2Corinthians 2:11, KJV), the spirit of rejection withered away. *"Being confident of this very thing, that he which hath begun a good work in you will perform it until the day of Jesus Christ"* (Philippians 1:6, KJV).

Now that I had gained true understanding of the real agape love of God, how could I have robbed myself from one of the greatest fruits that God has extended to his people? *"For God so loved the world that He gave His only begotten son that whosoever believeth in Him should not perish but have everlasting life"* (John 3:16, KJV). True love brings life, causes one to live again, and

surrender all to Abba Father.

If you remember, in the early part of my marriage I was not in love; however; the divine calling of God created a love in me for my husband, as Abba requires of wives. I'm not referring to the Eros love that's relative to infatuation – the outer attraction and lust for another, nor the phileo love which is predicated upon friendship and a shallow love that's conditional – the things that once interested us both. The agape love is what we all should have breathing through our hearts; if we say God lives in us, then it's to be shared...willingly! All those years spent protecting my heart from the very individual I came into union with, afraid of loving due to past experiences that held me hostage from truth and freedom. The love we now share through God has blossomed into a lovely rose.

As I paused to think, I had all the other love but not the untainted love of God. How sad? In this current season, giving my husband more attention was extremely important to me. Expressing my love to him without focusing on how he handled me was no longer a concern of mine because the way I treated him is also a ministry as it must please my Father which is heaven. Let me tell you this experience did not only help my marriage, but it has also brought growth when interacting with everyone I encounter.

Chapter 15

Having Awareness of the Camouflage Love

◆

"And we know that all things work together for good to them that love God, to them who are the called according to his purpose" (*Romans 8:28*). Count it all joy when you are chosen to enter into a season for the Potter to direct His creation...*His way*. *"Blessed is the man that endureth temptation: for when he is tried, he shall receive the crown of life, which the Lord hath promised to them that love him"* (*James 1:12*).

As believers, we know that Abba Father isn't the tempter; however, He permits the one who pursues and asks to test the chosen, to carry out his plots that it may work out for our good. Emmanuel (*God with us*) has fashioned His creation and is sure of His strength placed in His elect. He's already triumphed over the enemy at the cross of Calvary. The love of God strengthens, builds, reconstructs, corrects, prepares, and teaches, so that His chosen may press towards the mark of the high calling which is in Christ Jesus and gain wisdom and understanding of the enemy's devices.

Our Father sent His only begotten Son to endure all manner of trials, yet He sinned not. This was done just to speed up the process and to express His love for His people. There are a large number of people who lack true love. Many individuals are currently in the body of Christ yet are not aware of the agape

love – the love that causes them to realize He was there all along. Persons who do not understand the agape love will ruin healthy relationships. You find that they leave one relationship to the next as a continuous cycle. They take on a like spirit as a chameleon yet do not want to embrace the nature and policies that come with the hue of the untainted love. True love corrects. Moreover, God who's the word makes mention that *"no chastening seems to be joyful for the present, but painful; nevertheless, afterward it yields the peaceable fruit of righteousness to those who have been trained by it"* (Hebrews 12:11, KJV). *"For whom the Lord loves He chastens and scourges every son whom He receives. If you endure chastening, God deals with you as with sons; for what son is there whom a father does not chasten? But if you are without chastening, of which all have become partakers, then you are illegitimate and not sons (Hebrews 12:6-8 KJV)."*

Embracing the pure love of God makes you vulnerable because you desire to share your experiences that make you free. You wish for your neighbor to get to this place of enjoying their lives to the fullness. I learned very quickly that there were some assignments where only God could bring about the necessary changes. The divine calling of God allowed me to meet these chameleon spirits who housed pretentious love; they will only stay in your presence if you compromise the truth of who lives in you.

Be mindful that you may not be aware of its origin because it hides amongst a group of people and acts as if it's a comrade...not to mention that it camouflages itself as a

confidante. The divine calling of God is designed to bring His chosen into His perfect will, so as kingdom believers *we must incline our ears to wisdom, and apply our hearts to understanding, and cry out for discernment (Proverbs 2:2-3).*

"Hearing God's voice for yourself is a remarkable gift, that He may expose the hidden things to His beloved" (Everol Brackett). Allow the fire of God to consume your life and your atmosphere. The Hebrew boys were placed in the fiery furnace yet they did not get burnt, for what was designed to destroy them did not prevail. Why? Because Jesus was with them. When the fire of God overtakes your atmosphere, the pretentious spirit will become uncomfortable and flee from the fire. True believers will not run from the fire of God but trust while in the heat of its flames, for the fire of God will only purify them. As for the imposture spirit on the other hand, it will burn and cause them to flee from the true people of purpose. The agape love also prepares God's elect to say, *"Whatever you do, do it quickly!"*

Unawareness of the agape love can stem from people's past and can be a significant blockage to them expressing and receiving the kind of selfless love that comes with correction, teaching, and the exposure of things that are out of order in their lives and instead cause them to reject the truth that delays deliverance from the forces that have them bound.

Individuals who do not embrace the agape love will always have an open door for the enemy to use them against the ministry of the elect and chosen of God. The divine calling of God will cause your heart to feel heavy as it pertains to the things

involving the kingdom of heaven.

There's a time and season for everything. Abba who chooses will ask you like He did Samuel, *"How long will you mourn over the spirit of Saul?"* The spirit of Saul that was selected was positioned right next to God's elect Samuel. The spirit of Saul can only execute what's instructed by God through His chosen. The selection of man doesn't have what it takes to carry out specific assignments of the kingdom of heaven, but as for the elect – God's chosen, He is with them to complete *His* perfect will. The covering rests over the select and can be lifted by Abba who controls everything in his hand. The chosen comprehends what is at stake and have surrendered everything entirely to the Potter. They've recognized that operating in the flesh will cause them to lose everything, which is ultimately He who lives in them. The chosen has gone through certain levels of revelations where Abba Father has revealed Himself to them so they've learned not to take the authority of God lightly.

The spirit of Saul doesn't identify with pure love, so it lacks humility when it comes to the things of God. Saul did not yield to the instruction of the Almighty and that costed him the kingdom of Israel, *which was torn from him and given to his neighbor, who was better than him (1 Samuel 15:28).*

God designated one who understood his love for the sheep and directed Samuel to Jesse's house to anoint his son David. After the anointing process, there was no necessity for Samuel to stay with David as he did with Saul, for he was chosen, and

God was with him. "There's a difference between the covering of God and God being with you" (Everol Bracket). When you are chosen for purpose, the Saul spirit will find comfort being in your presence with the intentional hope that the anointing on your life will keep the spirit of torment off them – as it's too much to bear. While the anointing of God upon your life is keeping the Saul spirit refreshed, every now and then, the Saul spirit seeks to smite God's elect despite the love that is being expressed. You will find that it goes against spiritual authority, manifesting itself in the midst of others who are hearing from God.

When you set out to go and do ministry, the attacks comes up against you through that individual who houses this force. The Saul spirit walks in rebellion which is as the sin of witchcraft as well as stubbornness. The spirit of Saul will reject the word of the Lord if it's called out or exposed and does not like open rebuke. The word of God states *"Open rebuke is better than concealed love"* (Proverbs 27:5). These Saul-like chameleon spirits will make statements like "I don't think that was God" whenever the sword (*the word of God*) is turning towards it; however, it's okay to them when someone else...anyone else is uncovered. The divine calling of God will move Saul out of the picture entirely so that His will may be accomplished, and place someone else in the position who is of His own heart.

Chapter 16

Love Seats You at the Table for Betrayal

◆

Do not beat yourself up for having selfless (agape) love. It's not your fault that you've accepted the process for purpose and others willfully abort theirs. God does not present any trials in your path that you cannot handle. If Abba Father is with you, He'll present His perfect plans to His chosen, when He knows they are ready to accept what is designed to bring them into His picture-perfect will. Jesus Christ, who's the sacrificial lamb, didn't make it to the cross until the spirit of God which was placed in Him accepted His divine obligation. *"Then cometh Jesus with them unto a place called Gethsemane, and saith unto the disciples, sit ye here, while I go and pray yonder" (Matthew 6:32).* Staying at a place where you can hear your Father's directions for His will to be done is compulsory. *Jesus Christ acknowledged His purpose in the garden of Gethsemane. The bible states that the son of man went a little farther, and fell on his face, and prayed, saying, O my Father, if it is possible, let this cup pass from me; nevertheless, not as I will, but as thou wilt (Matthew 6:39).*

In order to complete the perfect plans of God, one must receive and extend agape love. Real love hurts because you house the heart of flesh. A stony heart doesn't feel what it would due to bitterness and ignorance of the things of the kingdom.

There's a cliché statement that *"love doesn't hurt"* but is that true? Have you ever extended love towards someone and they were only tolerating your presence because it benefits them? The reality is, they on no occasion had the capacity to express to you what they do not house. Take a moment to think about Christ who gave his life for us because He understood what was at stake. The very people whom He loved called Him everything but a child of God, walked alongside him but still had trust issues even as He performed signs and wonders in their presence. The pretentious spirits will even try to resurrect dead things from their past as an excuse to use them in their present lives, like as similarly to what Saul did with Samuel through the witch of Endo (1 Samuel 28:15). It takes a level of spiritual maturity to deny your flesh and embrace the touch of God that does not have any acquaintance with the anguish or agony the enemy would want you to accept as a norm.

The divine calling of God leads you through various processes for His intent. He then asks you a question to get your undivided attention. *The book of Matthew 21:15-17 states that "Jesus said to Simon Peter, Simon, son of Jonas, lovest thou me more than these? He said unto him, Yea, Lord; thou knowest that I love thee. He said unto him, Feed my lambs. He said to him again the second time, Simon, son of Jonas, lovest thou me? He said unto him, Yea, Lord; thou knowest that I love thee. He said unto him, Feed my sheep. He saith unto him the third time, Simon, son of Jonas, lovest thou me? Peter was grieved because he said unto him the third time, Lovest thou me? And he said unto him, Lord, thou knowest all things; thou knowest that I love thee. Jesus said unto him, Feed my sheep" (KJV).*

By way of letting go of the years of bitterness, my spirit developed much needed vulnerability. My understanding of the kingdom was now clearer because Abba began to teach me who He is through revelation (in an understandable way). I began to pursue the things of God and open my heart to be used by Him the more. On this beautiful sunny day, I was driving to pick my children up from school. While I was in the car preparing my heart to teach the word of God on the conference line, my spirit began to hum a well-known song "Is your all at the Altar of sacrifice" by LaShun Pace.

Is your all on the altar of sacrifice?
Of sacrifice laid?
Your heart does the Spirit control?
Now, u can only, only, only be blessed
And have peace and sweet rest
After you have yielded Him

Yielded Him your body and your soul

The question was asked "Afi, is your all at the altar of sacrifice? In my spirit I realized that my all wasn't laid at the altar. Sometimes we sing songs when we are not in tune with the place that individual's spirit was when the lyrics were being composed. The light bulb clicked that I too was telling God what I didn't want to do as if I was saying "let this cup pass." Abba had my attention for everything He allowed

me to do during my season of preparation and testing, this next level required all body and soul. When the time for the teaching on the conference line approached, I wept because my answer must now be *nevertheless*. With a repentant spirit, "Yes Abba, my all is at the alter – including my body and soul." Then and only then did I recognize that the very things I was telling my Heavenly Father I didn't want to accept, were exactly what awaited me.

God knows just what situation or person to use so that His plan may line up according to His will. Most of the times who and what He uses aren't even aware that they were in position for an assignment. Whatever the outcome, as spiritual beings in earthly vessels, *"we know that in all things God works for the good of those who love him, who have been called according to his purpose"* (Romans 8:28). *"He then seats you at the table in the presence of your enemy and anoints your head with oil"* (Psalm 23). The true love of God will test you where he places you at the table with Judas, the very ones you love which are called to thrust you into purpose. One who doesn't know what the untainted love of God is, will only take on like spirit. The spirit of Judas is selected and has the covering to complete and execute an assignment to shove you into the perfect will of God. Judas was amongst the disciples. He was placed alongside the others, but he had an open door for the enemy to use him.

"Jesus knew who would betray him; therefore, said he, Ye are not all clean" (John 13:11, KJV). Judas Iscariot was unaware that he was divinely placed in the company of Jesus so that Abba Father's divine intent may be completed. *John 13:18 states, "I*

speak not of you all: I know whom I have chosen: but that the scripture may be fulfilled, He that eateth bread with me hath lifted up his heel against me" (KJV). The time had come for the original intent of God to speed up, for the son of man had accepted purpose by saying, *"nevertheless let thy will be done."* The agape love must remain with you because *love covers a multitude of sins* (*1 Peter 4:8*). Jesus Christ loved Judas, but he was placed next to the others so that the original intent of the kingdom may speed up when the fullness of time arrived. After the soap was passed, Satan entered into him (Judas). *"Then said Jesus unto him, that thou doest, do quickly"* (*John 13:27, KJV*).

Chapter 17

All Things Work Together for Good

◆

It is obvious that whatever Abba Father orchestrates, it is done in excellence and to optimal perfection, to ensure that we comprehend the process as we are thrusted into our purposes. Divinity created the tree used to make the cross at Calvary. Can you imagine how the Creator nurtured this tree used to nail His only begotten Son so that it would be ready for the crucifixion? When you have pure love, you cannot utilize your past as a tool to hinder you from giving of what lives inside of you. Whatever energy one houses, is what they will demonstrate to others. If the spirit of Christ lives in you, He will govern, direct, and cause you to extend the true agape love of God. If you allow your past and all your encounters that have been distasteful throughout your journey to tag along and do not allow Abba Father to bring about deliverance, you will end up harboring things like a pretentious spirit, the spirits of rejection, deception, hate, division, and manipulation.

The divine calling of God will take you through processes so that you may learn of Him. The cross must be implemented so that purpose can be fulfilled. The course that you have experienced was really just preparing your spirit to be tried, simply put. The enemy seeks to use the ones you love who have

open doors for him to enter to attempt what he thinks would destroy your character, peace, and stop what was already written before the foundation of the earth. Simply put, the enemy is after the ministry in you! In fact, the divine calling of God requires you to not only learn of Him but also from Him. *He stated "Take My yoke upon you and learn from Me, for I am gentle and humble in heart, and you will find rest for your souls. My yoke is easy, and My burden is light" (Matthew 11:29-30).*

This is where one gain knowledge of all that Christ has humbled on earth that His grace and mercy to hover over His chosen generation daily. He was beaten and His flesh was torn into while having to carry a cross on his back to Calvary. They drove the nails through His hands and feet, a crown of thorns was placed on His head, He was pierced in His side, humiliated though He was the true King, and given unclean water to drink.

As you learn of Him, you should pick up your cross and carry it. Trust and believe that there's an assignment designed to bring God's will to fruition in your life, so embrace the journey and tell the enemy *"whatever thou doest, do it quickly!"* In other words, we must each carry our cross in order to execute God's perfect will over our lives. The journey to the cross will appear unbearable and will require you crucifying your flesh, and letting some people go that you love...*because some places you are called to walk, they cannot take that journey with you. "Simon Peter said unto him, Lord, whither goest thou? Jesus answered him, whither I go, thou canst not follow me now; but thou shalt follow*

me afterward" (John 13:36).

Above all, what you've encountered or are currently going through is designed to birth you into purpose, so continue to love amidst it all. The true love of God will fight on your behalf while the enemy is under the notion that he has prevailed. In the midst of love, there's often a like-spirit that brings deception and waits for the perfect time to rebel when their assignment is near completion. Don't look for the enemy to show remorse after the assignment given has been finalized.

The spirit of deception will try to taint your character to build a case against you. The goal is to kill the purpose and make your calling of no effect. For example, there were two brothers Cain and Abel. Abel had true love and God trusted him to tend to the flocks (goats and sheep) while Cain cultivated the ground. Abel brought his finest offering to the Lord; Cain presented his offering as well but it wasn't his best. As a result, God was very pleased with Abel's offering. Cain became extremely angry; the Lord asked him why such fury? The Lord told him to do what was acceptable and pleasing to Him, and he'd receive his offering. The Lord also told him, if he ignored the divine instructions, sin stooped at the door and desired to subdue him. In other words, as a chosen people we have master ignoring the enemy, do not internalize things in your head least you give the enemy an open door to gain leverage in the battlefield of your mind that will cause you to be angry. Cain waited until they were alone and killed Abel. He acted out of anger and did not yield to the voice of God. The Lord asked him of his brother's whereabouts, and he lied and said that he

didn't know. He did not have a repentant spirit. The spirit of anger was still in him, which responded and said, *"Am I my brother's keeper?"* The Lord let him know that his brother's innocent blood was crying out to him. True love bears witness for itself, so if your brother is hurting and you don't feel any compassion that means you never had the true love of God. You are an imposter that took on the formation of something that wasn't truly living inside of you.

Love is one of the greatest gifts given. Pray for those who despitefully use you and for those individuals who have made themselves available to the enemy and believe they can stop God's purpose. The agape love makes you look beyond others' faults and see their needs, just as Jesus Christ did for us. *Romans 13:8 states, "Owe no man anything, but to love one another: for he that loveth another hath fulfilled the law"* (KJV). The divine calling of God is being willing to let go of everything in the palms of the Creator's hands and sway whatever direction he deems fit. The celestial calling of God takes you through diverse testing, so that His people's hearts may turn back to His will by way of learning of Him while embracing the characteristics of the fruits of the Spirit. *"The fruits of the Spirit are love, joy, peace, longsuffering, gentleness, goodness, faith, meekness, temperance: against such there is no law"* (Galatians 5:22-23, KJV).

Love was tested on the cross so that the world may know how much Abba Father loves us. Prepare yourself for God is ready to make mention of your name. Because of love, I was seated at the table to be betrayed...for my Father had brought me into a new land – a completely different state...to be tried. I was

ignorant to what was to come and no family present.

Geographically, my family was now hundreds of miles away; furthermore, Abba staged His doings strategically, only I wasn't aware of what was about to transpire. Let me not go ahead of myself. Here I was at a place where purpose anticipated me and my cross set before me. The very thing, the son that God had used to build and restore my spiritual life and the union he was birthed from. The enemy tried to overtake and torment his mind. Notice I said *"tried."* Here was my son suddenly dealing with anxiety attacks, something he's never had an issue with. The very child the doctors told me wasn't responsive to the An Otoacoustic Emission (AOE test) & Auditory Brainstem Response (ABR) hearing test when he was born. The child I told the nurse that their screening method was ineffective. God proved them wrong through my faith in Him.

The first day the attack was launched, I took him to school and the school called me to pick him up because he was sick. I thought he was just having one bad day but that the next day he would be normal. Following the first attack, every day I took him to school, the nurse or counselor would be calling my phone a half an hour later. Lacking an appetite, thrusted me into turning my plate down and enter into a fast because I recognized that this was more than anxiety attacks; this was a spiritual battle. My son had no control over this conniving spirit that had snuck into his space.

It's amazing when the hedges are taken down, for Daddy

has confidence knowing that you have what is needed to withstand the obstacle and win...not because of the carnal strength, but instead having blessed assurance in He who is within me, knowing He's already won. Abba was working this storm out for his good whether we were immediately aware of that fact or not. Either way, the intent was to speed up His will for a generation. Men had their evaluations, but whose report was I going to believe? Ultimately my Abba Father's! With my cross before me, my eyes were opened to the fact that the ones I willingly supported when their storm raged, they too turned their backs in the midst of my current storm; however, once again we know that was also working out for my good and Abba's purpose so that He would get the full glory.

The school system was desirous of me taking him to be psychologically evaluated. One would say yes if they lacked understanding of God's strength; however, my confidence was anchored in Abba Father who placed His will in my womb and showed me His purpose, even in the gift that God gave me *to train up my child in the way he should go (Proverbs 22:6)*. My son, Nehemiah came in my life unexpectedly, where Abba hid him in my womb under the shadow of the Almighty. God revealed him to me in the fifth month of my pregnancy, as I stated earlier on in the book. I was not prompted in my spirit to place my son in the hand of man because I wasn't on drugs nor was I an alcoholic when I was carrying him in the matrix of my womb.

Moving forward, suddenly my son didn't want to attend school and wanted to be homeschooled within the last two

months he had left to graduate from elementary; it was too late to do such. Like any good mother, I was willing to do whatever it took to save my son from the system, laws of man, and the spirit of anxiety...so I did the one thing I knew how to do best – seek the face of Baba, my Heavenly Father. I also asked the school if I could become a volunteer so that he could see me periodically throughout the day, hoping it might convince him to complete each day. I took baby steps and focused on overcoming...*one day at a time.* I even asked his teacher if I could sit in her class. She was so understanding thankfully, so I was going there two days out of the week to sit in his class observing and volunteering. One day the test became so heavy and I was at my last. I sought Abba so deeply on this particular day. And yes...Abba answered! He had me at the position He desired, for the cross awaited me to pick it up...for purpose could no longer be delayed; the enemy had taken too much leverage. It was time for the enemy to launch his attack quickly. The spirit of the Lord kept saying **I WILL FIGHT FOR YOU**, but I was saying to myself "What are you waiting for God?" "This is a perfect time for you to jump in and stop this storm that isn't ceasing. Yet there I was once again with a nevertheless. I was given strategic directions to follow by Abba Father, to confront the spirit of rebellion and I saw my God fight for me immediately. He is a present help in the time of trouble! That same day Abba answered. I was reminded of the word of God, *"Son of man, behold, they of the house of Israel say, the vision that he seeth is for many days to come, and he prophesied of the times that are far off. Therefore, say unto them, thus saith the Lord God; There*

shall none of my words be prolonged any more, but the word which I have spoken shall be done, saith the Lord God" (Ezekiel 12:27-28).

The very child that Abba used to build me and restore my spiritual life was the very one he allowed the enemy to "try" because I knew what was at stake. I am the chosen and elect, and He is with me. Daddy was confident that the hedges coming down would push me into His presence, in a way that He would seat and prepare me for the higher level in Him – the mountain experience, a place of encountering His glory, learning the like spirit of others that isn't God, exposing my Judas while seated at the table, dying to my flesh and with love still being the main source of the divine calling of God. Abba won again. The storm isn't designed to kill or destroy if God is in it. He requires us swaying with the wind and a little bending to the knees, for you can't break.

Some days I would just pull into the garage and just scream out "Abba, where are you?" Then seconds would follow with a *nevertheless, do not let this cup pass*. In other words, *whatever thou doest, please do it quickly!* As believers we must stand against the wiles of the enemy. The enemy isn't a person but a spirit that seeks whomever it can devour. Most of all he's after your purpose and character. Hallelujah...Abba has won again! My question to you is, will you have a spirit of expectation to receive the blessing that Abba is ready to pass on to you, knowing that first you will and must be tried in the fire?

Are you equipped for your divine calling? If so, it requires a "nevertheless...anyway you do it...thy will be done...if I perish, I perish" mindset and confessions from the heart. These questions can only be answered by you and only you. Know where you stand with God. I pray that you will be ready for your journey into destiny. God's peace I leave with you.

References

http://www.webmd.com/multiple-sclerosis/guide/what-is-multiple-sclerosis

https://www.bartlett.com/resources/Plant-HealthCare-Recommendations-for-Live-Oak-inTexas.pdf

http://www.enchantedlearning.com/subjects/butterfly/anatomy/Caterpillar.shtml

Caterpillar Anatomy - EnchantedLearning.com, www.enchantedlearning.com/subjects/butterfly/anatomy/Caterpillar.shtml.

Biblegateway.com

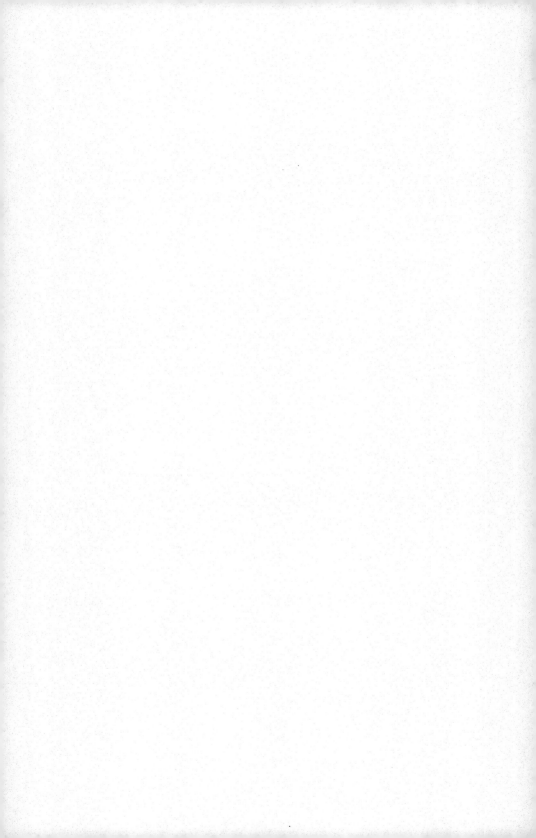

Printed in Great Britain
by Amazon

81815783R00079